# LONDON'S CRYPTS & CATACOMBS

ROBERT BARD & ADRIAN MILES

AMBERLEY

First published 2018

Amberley Publishing
The Hill, Stroud
Gloucestershire, GL5 4EP

www.amberley-books.com

British Library Cataloguing in Publication Data.
A catalogue record for this book is available from the British Library.

ISBN 978 1 4456 7869 6 (print)
ISBN 978 1 4456 7870 2 (ebook)

Origination by Amberley Publishing.
Printed in Great Britain.

# Contents

# Introduction

Have you ever wondered what lies beneath your feet when you walk into a church and walk over the grave markers on the church floor? Where are the bodies buried when you visit the royal tombs in Westminster Abbey? What do the crypts look like? Many of London's churches have crypts where the mortal remains of the wealthy have been placed over the centuries. The prime positions were located close to or under the altar. Until 1666 only the royal family and the aristocracy were interred in vaults, usually beneath a cathedral. Medieval monarchs were laid in tomb chests above ground, but Henry VII built a chapel at the east end of Westminster Abbey with chambers underneath in which the Tudor and Stuart sovereigns still lie. Many of these Westminster Abbey tombs were explored in the nineteenth century. What was revealed makes fascinating and sombre reading.

After 1666, most of the rebuilt churches were reconstructed with crypts that had areas the same size as the overall church floor area. Charging wealthy parishioners for the privilege of a crypt burial meant, for the clergy, that there was good money to be made. Malcolm Johnson, who has carried out a detailed study of crypt burials, believes that families were willing to pay large sums for these burials:

> Some hoped for an 'eternal bedchamber' because they knew that bodies in the churchyard would be dug up after thirty or so years and the bones placed in a charnel house when the space was needed for new burials. Others hoped the congregation worshipping above the crypt would continue to pray for them and many more were apprehensive that body-snatchers might plunder the churchyard. Yet, in crypts, bodies were sometimes tipped out of their coffins so that the lead could be sold together with the metal handles. However, burying the dead in an area frequented by the living had severe health consequences.

The introduction to the 1984–86 Spitalfields crypt excavation report contains some interesting observations on why crypts were popular with those that could afford them:

> Certainly there were strong personal reasons for being interred in a vault, William Hurlin, writing of his grandmother, Sarah Hurlin, who was interred in the crypt at

Christ Church in 1839 was of the opinion that 'she shrank from the idea of being buried in the earth'. The notion expressed here that earth burial is 'dirty', and that there was a repugnance towards it due to the knowledge that the flesh of the corpse would be consumed by worms and other small fauna, is easy for 20th century individuals to comprehend, for it is a common enough sentiment today ... Security of tenure seems to have enjoyed a high priority for the deceased during the 18th and 19th centuries. Burial in a churchyard posed two risks. Firstly, the actual tenure guaranteed by a church was limited, literally, by its turnover. Security of tenure seems to have enjoyed a high priority for the deceased during the 18th and 19th centuries ... As population increased, the number of dead needing disposal increased and churchyards became notoriously overcrowded. Not until the opening of the great metropolitan cemeteries in the 1830s did the situation begin to ease in urban churchyards. Even in 1853 Charles Dickens was able to evoke the grim atmosphere of a London churchyard: 'O, what a scene of horror!' 'There!' says Jo, pointing. 'Over yinder. Among them piles of bones, and close to that there kitchen winder! They put him very nigh the top. They was obliged to stamp upon it to git it in. I could unkiver it for you with my broom, if the gate was open. That's why they locks it, I s'pose', giving it a shake. 'It's always locked. Look at the rat!', cries Jo, excited. 'Hi, look! There he goes! Ho! Into the ground!' (*Bleak House*, 1853)

The second risk was posed by the 'resurrection men', or 'sack-em-up gentlemen' who operated in the capital. During the height of their activity, between 1750 and 1830, these operators supplied hospitals such as Guy's and St Bartholomew's, as well as small, private anatomy schools, with bodies for dissection and study ... Evidently the security provided by the walls of a crypt was an attractive alternative to the thought of being disturbed in this way Furthermore, the tenure for a space in a vault was generally very much longer than in a graveyard. Thomas Jervis, a silk thrower and trustee for the parish almshouse, witnessed the purchase of a vault by Philip Dutch, a relative of his. The deed, which still survives, records the right to bury in one of the unoccupied vaults at Christ Church in January 1735 'in perpetuity'. If interment in a burial vault was desirable, it was also expensive. The very expense may itself have provided an incentive for burial there: exclusivity. Indeed, the entire process and paraphernalia of death 'served to maintain the status quo and to reaffirm the traditional hierarchy of power and prestige' ... at least a part of the burial service might have been read in the crypt.[1]

The situation would get progressively worse until, by the 1850s, the London churchyards were overflowing, leading to concern about burial practice, the risk of disease and not to mention the offensive sights of poorly buried corpses in many London graveyards. Vaults were also full to bursting and in a number of London churches the smell given out was often noted by parishioners. These vault burials, however, have provided us in the twenty-first century with a valuable social archaeological resource.

Named and traceable individuals are the best instances we have of marrying archaeology and historical data. Vaults contain higher numbers of named individuals

than any other sites and provide unparalleled opportunities for understanding the history of the vault and social history of the parish. Burial vaults beneath the chancel were generally reserved for the incumbents and their families, whereas those beneath the nave aisles were 'private' vaults for the wealthier of the parishioners. A key question is when does the vault become the preferred place of burial in the parish? How does vault construction develop over time? By digitising all the coffins and linking this to a database of the coffin plate and osteological data, computer-generated plots of the development of the vault's use can be analysed in combination with historical records. The coffin furniture itself can provide important information on historical trends in style and art as well as the recorded facts, such as names and dates. The neglect and disuse of vaults, both specific and general, may be examined and thus the effects of historical occurrences such as changes in the law and population expansion may be seen. The general closure of vaults in 1853–54 does allow for occasional burials of family members, but were these burials actually placed with the rest of the family? Did they have a specific location within the vault, or were they just placed wherever there was space? Additionally, there is much to be learnt from decay processes in vault conditions. Why is it that in some vaults the wooden outer coffins survive very well, such as at St Mary Magdalene Church in Islington, while in others the level of preservation is poor, such as at Spitalfields, where the wooden coffins have collapsed? How, why and when were vaults cleared, 'tidied' and sealed?

Over the last fifty years many of these crypts have been cleared and the spaces transformed into cafés, such as St Martin-in-the-Fields in Trafalgar Square. It was here that the vicar allowed Charles II's mistress, Nell Gwyn, to be interred under the altar. The Spitalfields crypt was used as a day centre for the homeless but now houses the 'Café in the Crypt' and offers a space for meetings and events; while, in the case of St Luke's, after the clearance of 1,052 burials in 2000 the crypt became the home of the London Symphony Orchestra. St Bride's, Fleet Street, was cleared in the 1950s and a museum was created. The cleared remains are housed nearby in stacked cardboard boxes. Those burials that are not filed in museum boxes for research purposes have been reinterred in several of London's Victorian cemeteries.

A number of these cemeteries, commonly referred to as the 'Magnificent Seven', have catacombs. West Norwood and Kensal Green have substantial catacombs, while smaller catacombs can be found in the Brompton Cemetery. The Highgate Cemetery catacombs are above ground. Some of these are suffering from structural problems, but, where safe, are occasionally open to the public by way of organised tours.

Rarely do published histories of our churches mention these undercrofts. Obviously, it is possible to visit those churches that have survived and establish details of their crypts. For the churches that have not survived, the best descriptions of their crypts are often found in the faculties that authorised their destruction, and occasionally in the vestry minutes, which record the process of emptying the remains and transferring them to a cemetery. Written accounts are rare because few people, apart from the sexton, visited these dark dismal places.

The first crypt to be archaeologically recorded was Christ Church, Spitalfields, in 1984/5. Two learned reports of the Council for British Archaeology describe

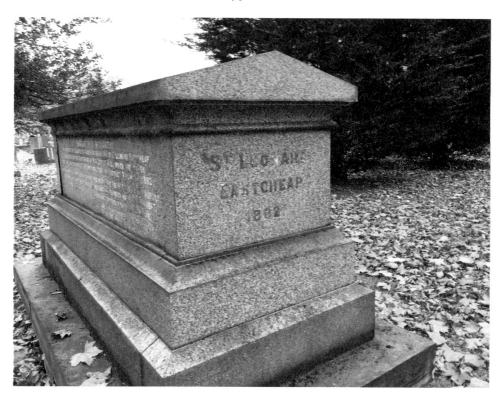

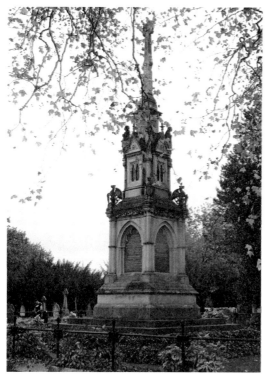

*Above*: Memorial in City of London Cemetery to St Leonard's Church, Eastcheap, Fish Street Hill graveyard near to The Monument. The occupants were exhumed to facilitate the building of the Metropolitan District Railway in 1882.

*Left*: Monument marking the reburial of individuals moved to City of London Cemetery.

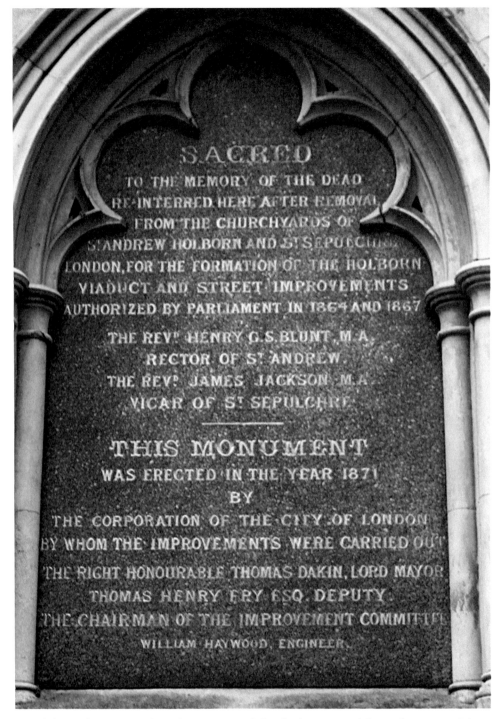

Detail from above: 'Sacred to the memory of the dead re-interred here after removal from the churchyards of St Andrew Holborn and St Sepulchre London, for the formation of the Holborn Viaduct and Street Improvements authorized by Parliament in 1864 and 1867 ... This Monument was re-erected in the year 1871 by the Corporation of the City of London.'

the clearance of coffins and remains from the crypt. Nearly a thousand bodies were carefully examined and researched. Interment in a crypt obviously preserves a corpse and coffin longer than if it was buried in a churchyard, but the state of preservation of those in coffins in the Spitalfields crypt varied from virtually complete, including skin, hair and internal organs, to just a sediment of crystal debris being all that remained of the bones. When lead was used, as it was in this crypt after 1813, this preserved the cadaver longer, but if air or water could penetrate then decomposition was much quicker.

Where were coffins and remains from crypts taken? Many went to the East London Cemetery in Plaistow or to the Great Northern London (now New Southgate) Cemetery. Some relatives were allowed to transfer the coffin of a family member to a burial ground of their choice, but most went to the City of London Cemetery, Ilford or to Brookwood in Surrey, the end destination of the Necropolis Railway.

Today, around half of London's crypts have been emptied. Some, such as that of St Martin-in-the-Fields, house a restaurant, bookshop and meeting rooms, which contribute a very large sum to the Parish Church Council. Others are chapels and columbaria, some are museums, while others have been left empty.[2]

We have included many unique photographs within this book, which give a haunting insight into the burial of our ancestors, along with a guide that takes the reader through the morbid and fascinating world of centuries of London's past inhabitants.

# An Overview of Burials

The costs of being buried in a stand-alone family vault, a church crypt or a cemetery catacomb were significantly higher than a standard churchyard burial. Generally, catacombs in London only come into use around the time of the closure of the central burial grounds under the terms of the Metropolitan Burial Act of 1852, which banned interments within the Metropolitan area after 1854.

For the purpose of definition, the burial vault is a subterranean chamber of stone or brick and is wide enough to allow at least two coffins to sit side by side. A structure which is the width of a single coffin is a brick-lined grave.[3]

Pressure for reforms to improve public hygiene resulted in churches limiting vault interments to lead-lined coffins only. For example, in the 1812 vestry minutes of Christ Church, Spitalfields, the committee recommended that as 'a very offensive effluvium proceeds from the public vault in its present state occasioned by the decay of the coffins and the consequent exposure of their contents, are of the opinion that no corpses should in future be deposited under the church, or steeple in the public or private vaults except such as are enclosed in lead on any account or pretence whatever'.

Edwin Chadwick, in his 1843 study of Metropolitan burial, gives several examples of funeral costs; those for lead-coffined burials vary from £121 5s for the top-of-the-range 'triple-shell' coffin with at least thirty-four men attending, through £62 5s for a triple-shell coffined funeral but with less elaborate attendances.[4] A guide for undertakers by Joseph Turner, published around 1838, gives the fees charged for interment in most of the burial grounds in London. Burial in the crypt was an expensive option compared with the churchyard.

The triple-shell coffin was most commonly used in vaults, the construction of which is described by Julian Litten:

The inner coffin was usually of elm and similar in type to the standard coffin of the period. The lead shell was made-to-measure in two common types. The 'smooth wrap' type was produced by placing the inner coffin on a width of lead which was then cut to be three inches larger all round than the coffin. This was then turned

up and tacked to the wood. A similar sized piece was then laid on the lid and the process repeated. The joints were then soldered together and smoothed, the heads of the tacks soldered also to maintain the airtight and water resistance of the coffin. The 'shoe box' type was produced the same way but with the sides being fitted before the lid. The coffin maker probably took the outer case from stock rather than hand making one. These were of similar type to the inner and were sumptuously upholstered and provided with elaborate coffin furniture, in the form of handles, lid motifs, coffin plates in lead or sometimes brass and studs to hold the covering in place. These all had to be attached before the insertion of the lead shell and had to be carefully positioned so as not to come into contact with the lead shell, grooves often being cut internally to prevent this. Great care was required to place the lead shell into the outer so as to avoid piercing or damaging it, it often requiring six men to lift it, with webbing, into position. Finally the lid was put into place and screwed or bolted down into countersunk holes. In many cases, cross-hatched incised lines can be found on the lead shell.[5]

Catacombs were never very popular in Britain; there is still space within the Kensal Green vaults for new interments, while the City of London Cemetery catacombs are only a third full. However, those at Norwood Cemetery were more used and appear to be near to capacity.

CHAPTER TWO

# Churchyard and Burial Ground Vaults

The family vault was another statement of the wealth and perceived standing of an individual in society. A churchyard vault was a less expensive option than a vault within the church, but still did not come cheap.[6] The construction of a vault took up a significantly greater area than a standard grave: not only was space required for the vault, but also ground had to be set out for a passage or entrance into it, in which ground no burials could take place so as not to hinder access to the entrance. The potential loss of income to the parish needed to be overcome.

St Marylebone was typical of most parishes. When their new burial round was opened in 1733 the vestry ordered that no ground for vaults in the churchyard was be sold for less than the fee agreed for vaults of 9 feet by 7 feet (2.74 metres by 2.13 metres).

In 1744 the fee for a double vault was set at £30. The dimensions of vaults were certainly enforced, as on 1 April 1746 it was reported to the vestry that George Mercer had built a vault and monument in the best ground part of the New Burial Ground, the dimensions of which were 9 feet by 7 feet. However, he had also laid a row of Purbeck paving around 18 inches wide around the monument, which extended it beyond the common dimensions, so he was obliged to take this up.

By 1759 the Hon. Richard Fitzpatrick Esq of Hanover Square had built a vault in the best ground of the New Burial Ground of 16 square feet (4.88 square metres), for which he had paid £60.[7]

On 29 November 1783 the sexton informed the vestry that in the future no brick grave of more than 3 feet 6 inches in breadth by 7 feet in length would be permitted in the burial grounds of the parish unless the applicants paid in proportion for the extra ground before any such grave or monument was built.

Along with the burial fees paid to the vestry for the grave space, the actual cost of the construction also had to be met. An example from St Marylebone from 1841 for the vault for the wife of Charles Morris had a cost of £19 8s.

However, following his death in 1844 a more elaborate and consequently more expensive structure was built, which required the removal of much of his wife's original brick grave. This came to a total cost just over £63.[8]

# Bunhill Fields

An inscription at the eastern entrance gate to the burial ground reads: 'This church-yard was inclosed with a brick wall at the sole charges of the City of London, in the mayoralty of Sir John Lawrence, Knt., Anno Domini 1665; and afterwards the gates thereof were built and finished in the mayoralty of Sir Thomas Bloudworth, Knt., Anno Domini, 1666.' The present gates and inscription date from 1868, but the wording follows an original seventeenth-century inscription at the western entrance that has since been lost. The earliest recorded monumental inscription was that to, 'Grace, daughter of T. Cloudesly, of Leeds. February 1666.' The earliest surviving monument is believed to be the headstone to Theophilus Gale; the inscription reads: 'Theophilus Gale MA / Born 1628 / Died 1678.' The ground appears on Rocque's 1746 map of London, and elsewhere, as 'Tindal's Burying Ground'.

The Victorian sanitary reforms of the 1840s and 1850s led to the closure of the metropolitan burial grounds between 1853 and 1854. The order to close Bunhill Fields was made in December 1853, and the final burial (that of Elizabeth Howell Oliver) took place on 5 January 1854. Occasional interments continued to be permitted in existing vaults or graves. The final burial of this kind is believed to have been that of a Mrs Gabriel of Brixton in February 1860. By this date approximately 123,000 interments had taken place in the burial ground.

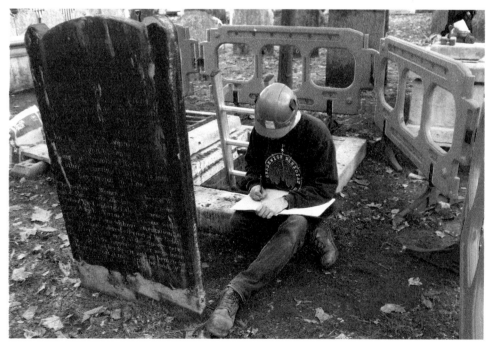

MOLA archaeologist recording the gravestone associated with a family burial vault in Bunhill Fields.

Bunhill Fields is the only central London burial ground that has largely survived Victorian landscaping. This usually followed the campaign of the Metropolitan Public Gardens Association from 1882 to 'provide breathing and resting places, for the old, and playgrounds for the young, in the midst of densely populated areas' by encouraging the conversion of disused churchyards and burial grounds into public gardens and parks. This led to the wholesale removal of gravestones and other memorials from the grounds, often to be placed against the boundary walls, used for paths or even taken away.

Bunhill Fields suffered the effects of bombing during the Second World War and damage was caused to some of the monuments. However, it was the 1960s landscaping of the ground that removed most monuments. The original intent was to remove all the monuments from the ground, but protests led to only the most damaged northern part of the ground having its stones removed. Some removals were also carried out to highlight the locations of the monuments of John Bunyan and Daniel Defoe. The remainder was left largely undisturbed and remains so today.

The burial ground has been recognised as a historic landscape, with a Grade I entry on the national Register of Historic Parks and Gardens. This allows for a record to made of any interventions required for conservation or safety reasons.[9]

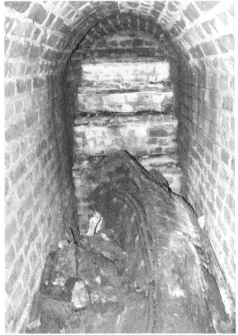

Occasional collapses within the burial ground allow an opportunity to examine what is below the visible monuments. The coffins within the vault below the monument have been recorded. This vault has now been repaired and the coffins left in place. (© MOLA)

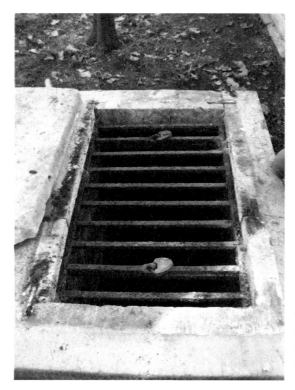

The entrance to a family vault in Bunhill Fields. This iron grate was located beneath a memorial slab and led down into the vault seen below. (© MOLA)

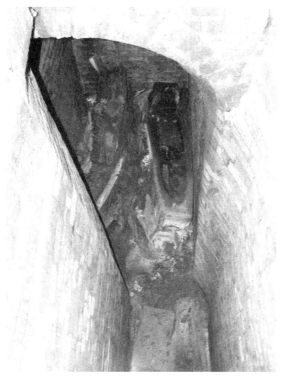

This deep and complex vault was found below the iron grate above. It was clearly in use for a long time and had been repaired and rebuilt during its lifetime. (© MOLA)

# Church Crypts

## Westminster Abbey: Account of the Search for James I's Grave

Arthur Penrhyn Stanley (1815–81) was Dean of Westminster from 1864 to 1881. His curiosity for what lay beneath the abbey's tombs became too much for him to resist and he began what would develop into a fascinating exploration. In 1868, probably on a pretext of uncertainty as to where James I was located and his desire to establish 'knowledge of the exact spots where the illustrious dead repose', he decided use a process of elimination to find the elusive king by opening up each of the royal vaults. Believing that James might share a vault with his mother Mary, Queen of Scots the dean burrowed into the crypts of Mary, Mary Tudor, her sister Elizabeth I, Edward VI and the numerous children of James II and of Queen Anne. The vault of James's wife Anne of Denmark was also located, but her coffin lay alone. He eventually found James I in Henry VII's vault. The keeper of the muniments and librarian at that time wrote:

> Night after night the Dean with a few of the Abbey staff was able to carry out his self-imposed task undisturbed. On one occasion the historian Froude was present. Speaking of it afterward he said 'it was the weirdest scene – the flaming torches, the banners waving from the draught of air, and the Dean's keen, eager face seen in profile had the very strangest effect. He asked me to return with him the next night, but my nerves had had enough of it'.
>
> After the death of Elizabeth I in 1603, the royal vaults were left without any name or mark to indicate their position. In 1866, for the first time, the names of the Royalty who lay below had their location inscribed immediately above their vaults. It also happened that both of these vaults had been visited within the memory of man. Whilst the Georgian vault had been seen in 1837, when it was opened by Dean Milman, for the removal of an infant child of the King of Hanover the vault of Charles II. was accidentally disclosed … in 1867, in the process of laying down the apparatus for warming the Chapel of Henry VII In removing for this purpose the rubbish under the floor of the fourth or eastern bay of the south stalls a brick arch was found.

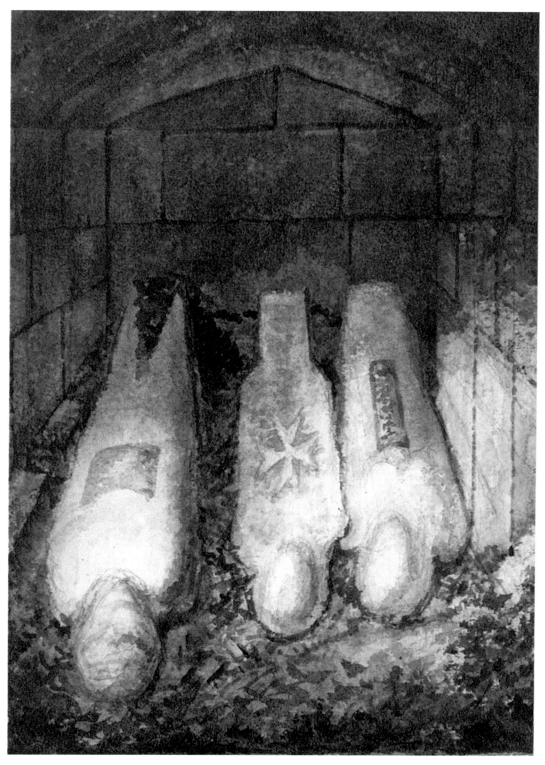

James I's coffin is on the left with Henry VII and his wife, Elizabeth of York.

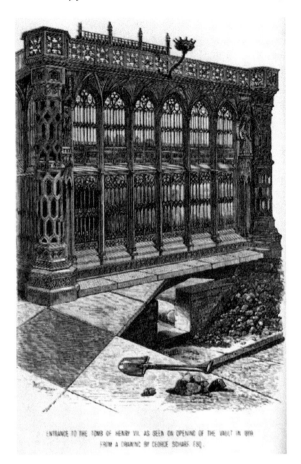

*Right*: The entrance to Henry Vll's tomb is seen in this image depicting the opening of the vault in 1869.

*Below*: The burial of Baroness Burdett-Coutts in Westminster Abbey in front of the statue of Lord Shaftsbury, 5 January 1907.

ENTRANCE TO THE TOMB OF HENRY VII. AS SEEN ON OPENING OF THE VAULT IN 1819
FROM A DRAWING BY GEORGE SCHARF ESQ.

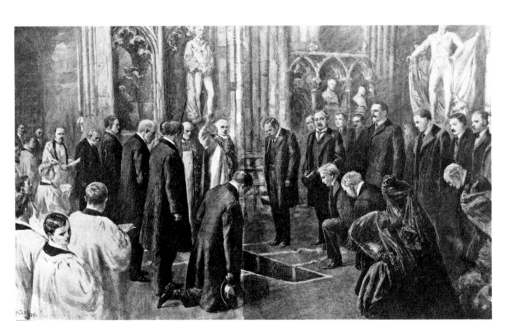

Dean Stanley wrote an account of his trawl through the crypts of Westminster Abbey, which we have abbreviated:

A small portion of the brickwork was removed, so as to effect an entrance sufficiently large to crawl in a horizontal posture into the vault. There was an incline toward the south, ending on a flight of five steps terminating on the floor of the chamber. Underneath a barrel vault of stone, laid as close as possible, side by side, and filling the whole space of the lower chamber from east to west, were the coffins of Charles II., Mary II., William III., Prince George of Denmark, and Anne, with the usual urns at the feet ... The wooden cases were decayed, and the metal fittings to their tops, sides, and angles were mostly loose or fallen. The lead of some of the coffins, especially that of Charles II., was much corroded; and in this case the plate had thus fallen sideways into the interior of the coffin. The inscriptions were examined and found to agree almost exactly with those in the Burial books...

The plates are of copper gilt, except that of Charles II., which was of solid silver. The ornamental metal fittings are expensively and tastefully wrought, especially those of Queen Mary. It is curious to observe the extreme simplicity of the inscriptions of William III. and his Queen in which, doubtless by the King's wish, the barest initials were deemed sufficient to indicate the grandest titles and also to contrast this with the elaborate details concerning the insignificant consort of Queen Anne. This accidental disclosure was the only opportunity which had been obtained of verifying the exact positions of any of the Royal graves; and the process of placing inscriptions in the other parts of the Chapel was suspended, from the uncertainty which was encountered at almost every turn. It was in the close of 1868, that Mr. Doyne C. Bell, of the Privy Purse Office, Buckingham Palace, who was engaged in an investigation of the Royal interments, called my attention to the singular discrepancies of the narratives and documents relating to the grave of James I. and his Queen...

I determined to take the opportunity of resolving this doubt with several others, arising, as I have already indicated, from the absence of epitaphs or precise records. In the anticipation of some such necessity, and at the same time in accordance with the long-established usage of the Abbey, as well as from a sense of the sacredness of the responsibility devolving on the guardian of the Royal Tombs, I had three years before entered into communication with the then Secretary of State, and obtained from him a general approval of any investigation which historical research might render desirable. The excavations were made under the directions of Mr. Gilbert Scott, the architect, and Mr. Poole, the master mason of the Abbey, on the spots most likely to lead to a result. The first attempt was at the north-eastern angle of Henry VII.'s tomb, which, as already mentioned, had been selected as the most probable site of the grave of James I. The marble pavement vault was lifted up, and immediately disclosed a spacious vault, with four coffins. But they proved to be those of the great Duke of Argyll and his Duchess, side by side; and resting on them, of their daughters, Caroline Campbell Countess of Dalkeith, and Mary Coke, widow of Viscount Coke, son of the Earl of Leicester. This discovery, whilst it was

the first check to the hope of verifying the grave of James I., was not without its own importance, even irrespectively of the interest attaching to the illustrious family whose remains were thus disclosed...

The search was now continued in the space between Henry VII.'s tomb and the Villiers Chapel; but the ground was found to be empty unoccupied and apparently undisturbed. Westward and southward, however, three vaults were discovered, two lying side by side opposite the eastern bay of the north aisle, and one having a descent of steps under the floor opposite the adjoining bay. The vaults were covered with brick arches, and the descent with Purbeck stone slabs. That nearest to the dais west of Henry VII.'s tomb, which it partly underlies, was found to contain one coffin of lead rudely shaped to the human form and attached to it was the silver plate containing the name and title of Elizabeth Claypole, the favourite daughter of Oliver Cromwell. This exactly tallied with the Elizabeth description given in the Burial Book discovered by Dean Bradford in 1728. The lead coffin is in good order, and the silver plate perfect. The letters in the inscription exactly resemble those on the plate torn from her father's coffin, and now in the possession of Earl De Grey. The vault of Elizabeth Claypole was probably made expressly to receive her remains; and it may be that, from its isolation, it escaped notice at the time of the general disinterment in 1661. But it is remarkable that the adjoining vaults were quite empty, and until now quite unknown...

It was now determined to investigate the ground in the Sheffield Chapel, which hitherto had been supposed to contain the Argyll vault. Records in Heralds' College distinctly state that Anne of Denmark was buried in a little Chapel at the top of the stairs leading into Henry VII.'s Chapel, there was a memorandum in the Abbey Burial Book, dated 1718, from which it might be inferred that the Queen was buried in the north-east corner of the Chapel. The pavement, which had evidently been disturbed more than once, was removed, and a slight quantity of loose earth being scraped away below the surface, at a few inches the stone-covering to a vault was found. A plain brick vault beneath was disclosed of dimensions precisely corresponding with the description given by Dart, as the vault of James I. and his consort. And alone, in the centre of the wide space, lay a long leaden coffin shaped to the form of the body, on which was a plate of brass, with an inscription exactly coinciding with that in the Burial Book of 1718, and giving at length the style and title of Anne of Denmark. The wooden case had wholly gone, and there were no remains of velvet cloth or nails. The vault appeared to have been carefully swept out, and all decayed materials removed, perhaps in 1718, when the inscription was copied into the Abbey Register, and the measurement of the vault taken, which Dart has recorded; or even in 1811, when the adjoining Argyll vault was last opened, when the stone (a Yorkshire flag landing) which covered the head of the vault, may have been fixed; and when some mortar, which did not look older than fifty years, may have fallen on the coffin-plate. The length of the leaden chest (6 feet 7 inches) was interesting, as fully corroborating the account of the Queen's remarkable stature. There was a small hole in the coffin, attributable to the bursting and corrosion of the lead, which appeared also to have

collapsed over the face and body. The form of the knees was indicated. On examining the wall at the west end of this vault, it was evident that the brickwork had been broken down, and a hole had been made, as if there had been an endeavour to ascertain whether any other vault existed to the westward. The attempt seems to have been soon abandoned, for the aperture was merely six or eight inches in depth. It had been filled in with loose earth. On turning out and examining this, two leg bones and a piece of a skull were found. It was thought, and is indeed possible, that these had been thrown there by accident, either when the Parliamentary troops occupied the Chapel, or on either of the more recent occasions already noticed. But in the contemplation of this vault, evidently made for two persons, and in which according to the concurrent testimony of all the printed accounts, the King himself was buried with the Queen, the question arose with additional force what could have become of his remains; and the thought occurred to more than one of the spectators, that when the Chapel was in the hands of the Parliamentary soldiers, some of those concerned may well have remembered the spot where the last sovereign had been buried with so much pomp, and may have rifled his coffin, leaving the bare vault and the few bones as the relics of the first Stuart King. With so strange and dark a conclusion as the only alternative, it was determined to push the inquiry in every locality which seemed to afford any likelihood of giving a more satisfactory solution. The first attempt was naturally in the neighbourhood of the Queen's grave. A wall was found immediately to the east, which, on being examined, opened into a vault containing several coffins. For a moment it was thought that the King, with possibly some other important personages, Sheffield was discovered. But it proved to be only the vault of the Sheffield monument. The discovery was a surprise, because the Burial Register spoke of them as deposited in the Ormond vault. The coffins were those of the first three Duke and Duchess of Buckinghamshire and three of their children, and also the second and last Duke, at 'whose death, lamented by Atterbury and Pope, and yet more deeply by his fantastic mother, all the titles of his family became extinct, the vault was walled up, although 'where the steps were there was room for eight more'. This 'room' was afterwards appropriated by the Argyll family, as before stated. Amongst the places of sepulchre which it was thought possible that James I. might have selected for himself was the grave which with so much care he had selected for his mother, on the removal of her remains from Peterborough to Westminster; and as there were also some contradictory statements respecting the interments in her vault, it was determined to make an entry by removing the stones on the south side of the southern aisle of the Chapel, among which one was marked WAY. This led to an ample flight of stone steps trending obliquely under the vault of the Queen of Scots' tomb. Immediately at the foot of these steps appeared a large vault of brick 12 ft. long, 7 ft. wide and 6 ft. high. A startling, it may almost be said an awful, scene presented itself. A vast pile of leaden coffins rose from the floor; some of full stature, the larger number varying in form from that of the full-grown child to the merest infant, confusedly heaped upon the others, whilst several urns of various shapes were tossed about in irregular positions throughout the vault. The detailed account of this famous

sepulchre given by Crull and Dart at once facilitated the investigation of this chaos of royal mortality. This description, whilst needing correction in two or three points, was, on the whole, substantiated. The first distinct object that arrested the attention was a coffin in the north-west corner, roughly moulded according to the human form and face. It could not be doubted to be that of Henry Frederick Prince of Wales. The lead of the head was shaped into rude Prince of Wales features, the legs and arms indicated, even to the forms of the fingers and toes. On the breast was soldered a leaden case evidently containing the heart, and below were his initials, with the Prince of Wales's feathers, and the date of his death (1612). In spite of the grim and deformed aspect, occasioned by the irregular collapsing of the lead, there was a life-like appearance which seemed like an endeavour to recall the lamented heir of so much hope. Next, along the north wall, were two coffins, much compressed and distorted by the super incumbent weight of four or five lesser coffins heaped upon them. According to Crull's account, the upper one of these two was that of Mary Queen of Scots, the lower that of Arabella Stuart. But subsequent investigation led to the reversal of his conclusion. No plate could be found on either. But the upper one was much broken, and the bones, especially the skull, turned on one side, were distinctly visible thus agreeing with Crull's account of the coffin of Arabella Stuart. The lower one was saturated with pitch, and was deeply compressed by the weight above, but the lead had not given way. It was of a more solid and stately character and was shaped to meet the form of the body like another, which would exactly agree with the age and rank of Mary Stuart. The difficulty of removing the whole weight of the chest would of itself have proved a bar to any closer examination. But, in fact, it was felt not to be needed for any purpose of historical verification, and the presence of the fatal coffin which had received the headless corpse at Fotheringhay was sufficiently affecting, without endeavouring to penetrate farther into its mournful contents. It cannot be questioned that this, and this alone, must be the coffin of the Queen of Scots. Its position by the north wall; close to Henry Prince of Wales, who must have been laid here a few months after her removal hither from Peterborough; its peculiar form; its suitableness in age and situation, were decisive as to the fact. On the top of this must have been laid Arabella Stuart in her frail and ill-constructed receptacle. And thus for many years, those three alone (with the exception of Henry of Charles I.'s two infant children) occupied the vault…

It may be conjectured that whilst Mary lies in her original position, Henry Prince of Wales must have lain in the centre of the vault by her side and removed to his present position when the introduction of the two larger coffins now occupying the centre necessitated his removal farther north. Of these two larger coffins, the printed account identified the lower one as that of Mary Princess of Orange; the plate affixed to the upper one proved it to contain Prince Rupert, whose exact place in the Chapel had been hitherto unknown. Next to them, against the south wall, were again two large coffins, of which the lower one, in like manner by the printed account, was ascertained to be that of Anne Hyde, James II.'s first wife, and that above was recognised by the plate, still affixed, to be that of Queen Elizabeth of Bohemia. Her brother Henry in his

last hours had of cried out; 'Where is my dear sister?' and she had vainly endeavoured, disguised as a page, to force herself into his presence. Fifty eventful years passed away, and she was laid within a few feet of him in this their last home. Spread over the surface of these more solid structures lay the small coffins, often hardly more than cases, of the numerous progeny the children of that unhappy family, doomed ... the ten children of James II., including one whose existence was unknown before, James Darnley, a natural son, and the eighteen children of Queen Anne; of whom one alone required the receptacle of a full-grown child William Duke of Gloucester. His coffin lay on that of Elizabeth of Bohemia and had to be raised in order to read the plate containing her name. Of these, most of the plates had been preserved, and (with the two exceptions of those of James Darnley and of Prince Rupert) were all identical with those mentioned in Crull. The rest had either perished, or, as is not improbable, been detached by the workmen at the reopening of the vault at each successive interment. It was impossible to view this wreck and ruin of the Stuart dynasty without a wish, if possible, to restore something like order and decency amongst the relics of so much departed greatness. The confusion, which, at first sight, gave the impression of wanton havoc and neglect, had been doubtless produced chiefly by the pressure of superincumbent weight, which could not have been anticipated by those who made the arrangement, when the remains of the younger generations were accumulated beyond all expectation on the remains of their progenitors. In the absence of directions from any superior authority, a scruple was felt against any endeavour to remove these little waifs and strays of royalty from the solemn resting-place where they had been gathered round their famous and unfortunate ancestress. But as far as could be they were cleared from the larger coffins and placed in the small open space at the foot of the steps. This vault opened on the west into a much narrower vault, under the monument of Lady Margaret Lennox, through a wall of nearly 3 feet in thickness by a hole which is made about 8 feet above the vault floor, and about 2 feet square. A pile of three or four of the small chests of James II.'s children obstructed the entrance, but within the vault there appeared to be three coffins one above the other. The two lower would doubtless be those of the Countess and her son Charles Earl of Lennox, the father of Arabella Stuart. The upper coffin was that of Esme Stuart, Duke of Richmond, whose name, with the date 1624 was just traceable on the decayed plate. On the south side of this vault there was seen to have been an opening cut, and afterwards filled up with brickwork. This probably was the hole through which, before 1683, in Keepe's time, the skeleton and dry shrivelled skin of Charles Lennox, in his shaken and decayed coffin, was visible. It is remarkable that the position of the vault is not conformable with the tomb above, the head of the vault being asked two or three feet to the south. This is evidently done to effect a descent at the head, which could not otherwise have been made, because the foundation of the detached pier at the west end of the chapel would have barred that entrance; and no doubt if the pavement were opened beyond the inclined vault, the proper access would be discovered.

It was suggested that there was every reason for exploring the space at the east end of the aisle between the tombs of Queen Elizabeth and those of the King's

own infant daughters. This space had accordingly been examined at the first commencement of the excavations but proved to be quite vacant. There was not the slightest appearance of vault or grave. The excavations, however, had almost laid bare the wall immediately at the eastern end of the monument of Elizabeth, and through a small aperture a view was obtained into a low narrow vault immediately beneath her tomb. It was instantly evident that it enclosed two coffins, and two only, and it could not be doubted that these 2 contained Elizabeth and her sister Mary. The upper one, larger, and more distinctly shaped in the form of the body, like that of Mary Queen of Scots, rested on the other. There was no disorder or decay, except that the centering wood had fallen over the head of Elizabeth's coffin, and that the wood case had crumbled away at the sides and had drawn away part of the Queens decaying lid. No coffin-plate could be discovered of Elizabeth but fortunately the dim light fell on a fragment of the lid slightly carved. This led to a further search, and the original inscription was discovered. There was the Tudor Badge, a full double rose, deeply but simply incised in outline on the middle of the cover; on each side the august initials E E; and below, the memorable date 1603. The coffin-lid had been further decorated with narrow moulded panelling. The coffin-case was of inch elm; but the ornamental lid containing the inscription and panelling was of fine oak, half an inch thick, laid on the inch elm cover. The whole was covered with red silk velvet, of which much remained attached to the wood, and it had covered not only the sides and ends, but also the ornamented oak cover, as though the bare wood had not been thought rich enough without the velvet. The sight of this secluded and narrow tomb, thus compressing in the closest grasp the two Tudor sisters, 'partners of the same throne' and grave, sleeping in the hope of resurrection the solemn majesty of the great Queen thus reposing, as can hardly be doubted by her own desire, on her sister's coffin was the more impressive from the contrast of its quiet calm with the confused and multitudinous decay of the Stuart vault, and of the fulness of its tragic interest with the vacancy of the deserted spaces…

# Wren Churches

## Church of St Andrew Holborn

The first mention of the Church of St Andrew Holborn was in AD 959; however, when the crypt was excavated in 2001, Roman remains were found below the tower, so the site could have been in use for nearly 2,000 years.

The project to exhume the burials from the crypt of the Guild Church of St Andrew Holborn during 2001–02 was initiated both to prevent further deterioration of the structure of the church and to provide a new community space.

The church was bombed during the Second World War and during the rebuilding of it tons of rubble and other debris were dumped into the crypt, covering the contents and causing considerable damage to a number of the coffins. The rubble was soaking up moisture and transmitting it to the whole church.

The crypt of St Andrew Holborn extends under the entire area of the church building, with the main bays of the crypt corresponding to those in the church. A total of 1,794 interment were removed from the crypt, of which 1,078 were in lead-lined coffins. A total of 995 of these individuals could be identified from their coffin breastplates.[10] The burials were reinterred in City of London Cemetery (Grave 25001, Square 210) around the existing monument. This had been erected in 1872 when the construction of Holborn Viaduct forced the removal of 11,000 to 12,000 bodies from the north churchyard. The monument has been updated to reflect the latest arrivals.

The lead coffins were a temptation for both the clerical and the criminal classes.

On Wednesday 23 September 1747 – John Bagnel, John Chandler and Charles Hooper were committed to Wood Street Compter and William Bilby, the Gravedigger of St Andrew's Holborn, to Newgate for feloniously being concerned in stealing divers leaden Coffins out of the Vaults of the said Church. They had taken 150 Coffins and had taken the Bodies out and made a Hole in the ChurchYard and buried them some of which had not lain there above a Month or two and others several Years as those of Dr Sacheverel and Sally Salisbury The Constable searched the House of john Lamb the Sexton and found 13 Coffins there. The Rev Mr Barton the Rector offered a Reward of 10 Guineas for apprehending him and he was soon after taken and

*Above*: The Church of St Andrew Holborn, looking towards Holborn Circus.

*Right*: The vault under the sanctuary of St Andrew Holborn – probably the vicar's vault. (© MOLA)

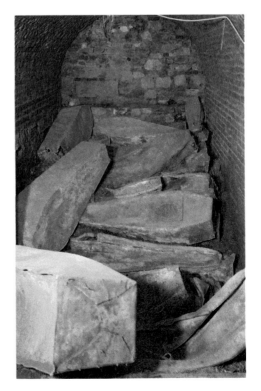

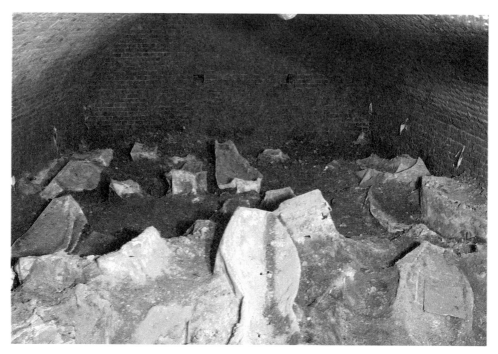

One of the large vaults under the nave of St Andrew Holborn, which contained over 400 coffins, mostly lead-lined. (© MOLA)

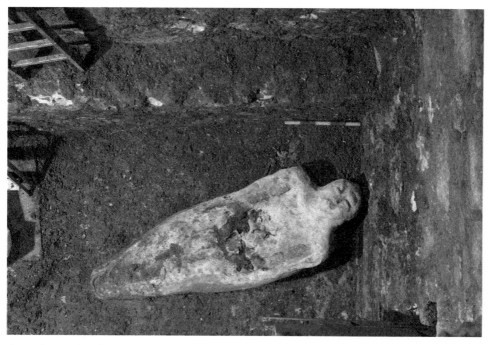

An anthropoid coffin found in an earth grave under the north vestry. This dates to *c.* 1650 and was probably moved during rebuilding of the church after the Great Fire in 1666. (© MOLA)

committed to Newgate At their trial on 14 October evidence was given by several men who had assisted in the operation under the impression that the Revd Geoffrey Barton, the rector, had ordered the removal. Bilby persuaded the rector that because the crypt was waterlogged a hole should be made in the outer wall for drainage. It was through this hole that bodies were dragged at night to be thrown into a pit in the churchyard, while the lead from the coffins was cut up and taken to the men's houses; when the constable visited them he found a hundredweight of lead worth 13s (£150). The two men were sentenced to seven years' transportation, but their helpers were acquitted.[11]

The anthropoid coffin recorded was of a type that was associated almost exclusively with the burial vault. They became fashionable in the fifteenth century and were still to be seen in some areas in the last decade of the seventeenth century, although they were beginning to decline in popularity during the 1660s and 1670s.[12] Two similar examples from London are both from the seventeenth century: one from Austin Friars and one noted by Litten as dated *c.* 1630.[13] A radiocarbon date has been obtained for the skeleton recovered from the anthropomorphic coffin, which showed it to date from 1640 to 1660.

# St Bride's Church

St Bride's Church has a long and interesting history and has been a pivotal place of worship within the City of London for many hundreds of years. It has administered during this long period to the living and dead and is still an active church today.

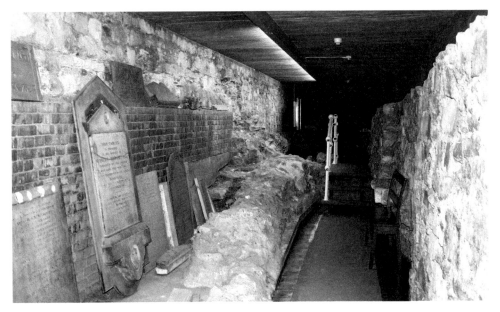

St Bride's Crypt.

Excavations were carried out in St Bride's Church in the 1950s because of bomb damage incurred to it during the Second World War. They revealed the church's long history of building phases and a large number of skeletal remains from a medieval charnel house, along with individuals interred in the crypts. The crypt space for burials was created by Wren in his design of the church after the Great Fire of London in 1666 had destroyed the previous church.

William Redpath was chairman of the Publicity Committee of St Bride's during the post-war restoration. He notes that, 'six inches below the level of Wren's church, we began to uncover skeletons and lead coffins, most of which had beautifully engraved inscriptions.' During the excavations, seven sealed vaults or crypts were found, including two charnel houses, dating from the medieval period up to 1750. The London Survey Committee volume on St Bride's Church – published in 1944, before the excavations took place – listed the monuments and wall tablets that were present within the church and where they were located. These identify several individuals buried within the crypt.[14]

There is a documented collection of the skeletons recovered from the lead coffins found during the excavation work carried out in the 1950s, which is retained in a special area within the crypt. Unfortunately, only the coffin breastplates were retained. Most of the coffins collapsed on being moved and the lead was sold to raise money for the restoration fund.[15]

The skeletal remains from St Bride's form a unique and valuable assemblage, given the detailed biographical data available for 227 of the individuals buried there. Access to the skeletal remains is not available to the public but has made available to academics for research projects.

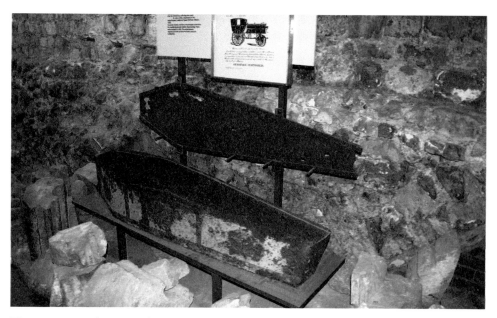

The museum in the crypt of St Bride's Church traces its history back to Roman times. An iron coffin from the crypt is also on display.

# St James Garlickhythe

In September 1991 a tower crane from a construction site on the opposite side of Thames Street fell through the roof of St James Garlickhythe. As part of the required repairs to the building, a void was found on the north east side of the church, which required consolidation.

On inspection this was found to be a brick barrel-vaulted burial chamber containing five lead coffins, in two stacks.[16] While some disturbance of the top coffins was evident the others seemed to be pretty well intact.

To the west end was an entrance that had been cut through the foundations of the church. Along the passage, under the body of the church, the entrance to the vault could be seen, although it was not possible to locate the feature within the church, due both to the reconstruction work at present being carried out and to the addition of a wooden floor over the area. This consisted of two stone slabs supported by brickwork, with a brick arch leading into the vault. It is probable that access was gained by lifting the slabs within the church and lowering the coffins down via ropes. A ladder could then be used to allow the interers to move the coffins around within the vault.

The church houses a well-preserved mummy of an older man, known as 'Jimmy Garlick'. His embalmed body was discovered in the vaults in 1855. Analysis by the British Museum postulated that he was an adolescent who died at the turn of the eighteenth century. The body used to be on display in a glass cabinet, but has now been closed to public view. In 2004, Jimmy Garlick featured in the Discovery Channel documentary series *Mummy Autopsy*, which used modern analytical techniques, including carbon dating and X-ray analysis, which established that he died between 1641 and 1801 and that he suffered from osteoarthritis, a disease that afflicts older people.

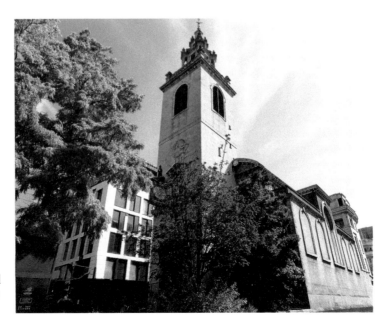

St James Garlickhythe viewed from Upper Thames Street.

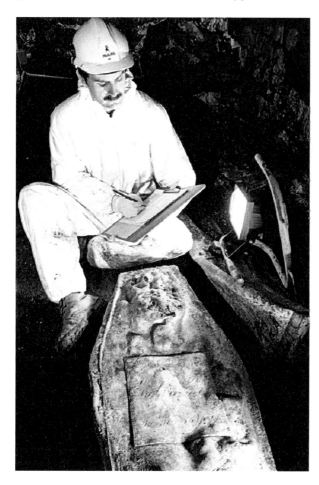

MOLA archaeologist recording within the vault on the north side of St James Garlickhythe, which came to light following a tower crane falling onto the church. (© MOLA)

## St Lawrence Jewry

St Lawrence Jewry, next to the Guildhall in the City of London on Gresham Street, was destroyed in the Great Fire of London in 1666 and rebuilt to the designs of Sir Christopher Wren. It is the official church of the Lord Mayor of London. The church was originally built in the twelfth century and dedicated to St Lawrence. It is near the former medieval Jewish ghetto centred on the street named Old Jewry.

During work on relaying the Guildhall Yard in 1997, a sealed-up burial vault at the east end of St Lawrence Jewry came to light. Archaeological work took place in spring 1998. The brief was limited to assistance in the controlled removal of some sixty lead-lined coffins dating from the early to mid-nineteenth century, and the subsequent recording of the masonry and brick structure of the vaults. The site lay over a scheduled ancient monument and so no excavation was permitted. Nevertheless, much new information was obtained. All the coffins were taken, unopened, for reburial elsewhere, but nearly all of them were found with names and dates on affixed coffin breastplates. The vault itself was protected and preserved.[17]

St Lawrence Jewry, on the southern edge of Guildhall Yard.

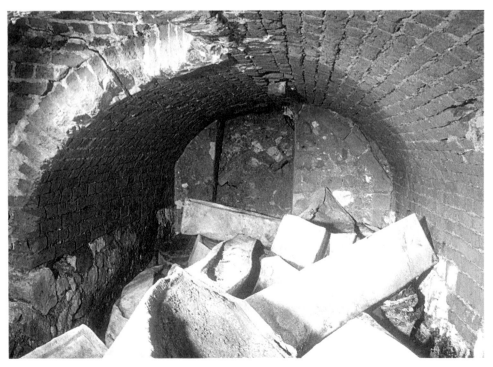

A small vault at the eastern end of St Lawrence Jewry, which appeared during works carried out to relay the surface of Guildhall Yard. (© MOLA)

CHAPTER FIVE

# Fifty New Churches

In 1711, an Act for the building of fifty new churches was passed to accommodate the rapidly increasing population of the city. These were to be funded by an additional duty on coals brought into the Port of London, originally levied to pay for the rebuilding of St Paul's Cathedral. A commission was set up to oversee the project.[18] In the event, only twelve were built. Most of these twelve were designed by Nicholas Hawksmoor, with John James, Thomas Archer and James Gibbs also contributing. Many of them have crypts below that merit inclusion here.

## Christ Church, Spitalfields

Christ Church, Spitalfields, was one of those constructed in 1711. It was consecrated in 1729 and the first burial known to have taken place in the crypt took place on 3 August 1729.

Christ Church is probably the most well-known crypt in Britain, from an archaeological perspective. The work carried out by Jez Reeve and Max Adams during the 1980s was the first full excavation carried out in a post-medieval crypt, and still remains one of a very small number.

Excavations recorded nearly 1,000 interments, of whom more than 400 could be identified. The project also took a detailed look at all the elements of eighteenth- and nineteenth-century burial, such as burial clothing, coffin construction methods and coffin furniture (including breastplates, coffin handles, grips, and other decorations). The publication still forms the basis of the typology of many of these items.[19]

The exhumation showed the state of preservation of those in coffins varied from virtually complete (including skin, hair and internal organs) to a sediment of crystal debris being all that remained of the bones. If lead had been used, as it was in this crypt after 1813, this preserved the cadaver longer, but if not fully sealed then air or water that penetrated would speed decomposition.

At the end of this work and the earlier unsupervised clearances in the 1960s, three small vaults remained that contained burials. The continuing restoration work being carried out on the church and crypt in 2003 meant that these vaults needed to be cleared.[20]

Another burial vault was discovered during external works associated with the renovations, located directly against the east wall of the church. This contained a total of seven coffined burials in three layers – six adults and one infant.

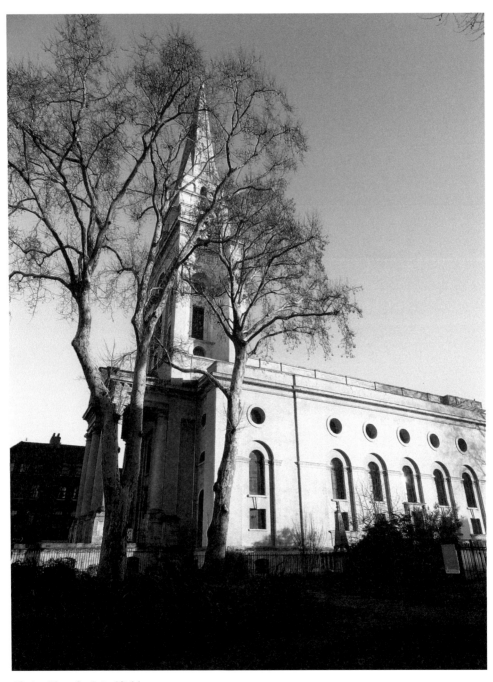

Christ Church, Spitalfields.

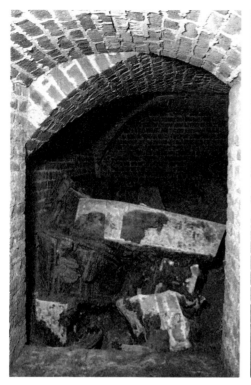

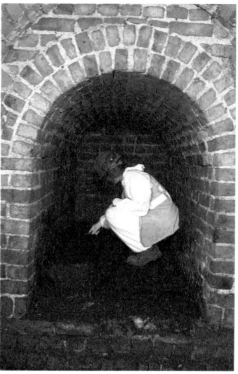

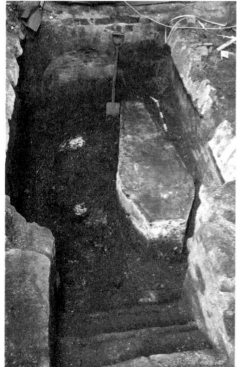

*Above left*: One of the three small vaults at Christ Church that were recorded in 2003. (© MOLA)

*Above right*: It was discovered that coffins had been placed in the arches through the foundations of the church wall. (© MOLA)

*Left*: An external family vault found up against the east wall of Christ Church, Spitalfields, which came to light during work to improve disabled access to the church. (© MOLA)

# St Anne's Limehouse

St Anne's was built between 1714 and 1727, and was one of the twelve churches built through the Fifty New Churches Act. The church was designed by Nicholas Hawksmoor and was consecrated in 1730.

Queen Anne decreed that as the new church was close to the river it would be a convenient place of registry for sea captains to register vital events taking place at sea; therefore, she gave St Anne's Limehouse the right to display the second most senior ensign of the Royal Navy, the White Ensign.

The church was gutted by fire on Good Friday 1850 and restored between 1851 and 1854 by Philip Hardwick. The roof and tower were restored further in 1983 and 1993. The main body of the crypt no longer contains any burials, but a number of smaller brick-sealed family vaults are located around the edges, placed behind wooden doors. There are two additional communal vaults in the area below the tower.

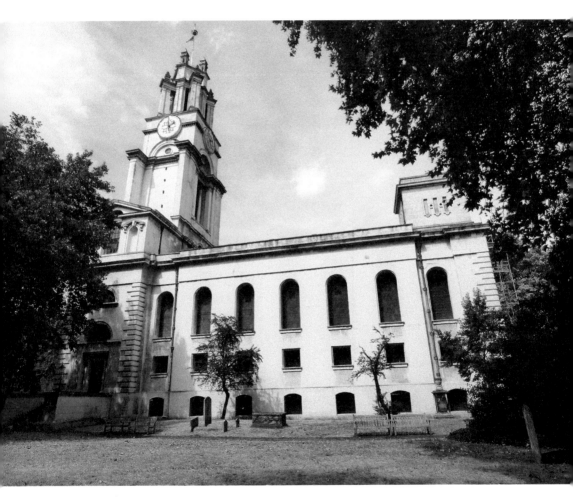

St Anne's Limehouse.

*Above*: The main area of the crypt of St Anne's Limehouse. It was used as an air-raid shelter during the Second World War.

*Left*: The unusual layout of the crypt of St Anne's Limehouse has brick family vaults behind wooden doors. The memorial plaque is situated above the door.

# St George's, Bloomsbury

St George's, Bloomsbury, is another of the Hawksmoor-designed churches. Construction began in 1716 and it was consecrated in 1730, although it was only fully completed in 1731. Archaeological recording of the crypt and its contents was carried out in 2003, in advance of restoration of the crypt. Within the seven vaults and the central chamber a total of 781 burials were discovered, dating between 1800 and 1856, after which the crypt was sealed.[21] The remains were taken away for reburial. The bodies recovered represented upper-middle-class residents of Bloomsbury and included many lawyers, doctors, MPs, imperial administrators and librarians of the nearby British Museum. There was also a servant, butcher and carpenter.

The Museum of Comedy opened in 2014 in the crypt. It features an exhibition room and a performance space that seats eighty-one people. The space is in use for shows every night for comedy performances – from theatre and stand-up, to radio recordings and silent film. The museum has over 6,000 items from some the most iconic comedians and comedy shows of both past and present, such as Charlie Chaplin's cane and the Two Ronnies' glasses.

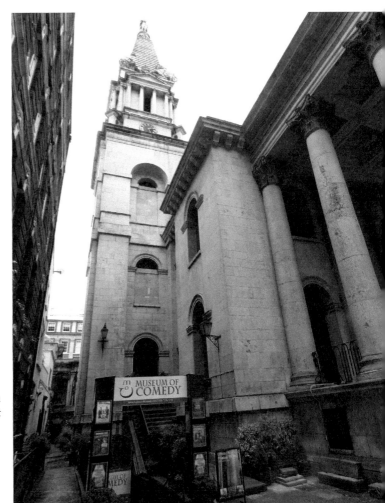

St George's, Bloomsbury, seen with the entrance to the crypt that is now the home of the Museum of Comedy.

## St Luke Old Street

St Luke Old Street was built to meet the growing requirements of that part of the town, the parish being taken out of the St Giles Cripplegate parish. The land to build the church was acquired from the Ironmongers Company for £900, although the progress towards construction was a long process.

The architect of the church is traditionally disputed. The body of the church is possibly by John James; the west tower, spire and flanking staircase wings by Nicholas Hawksmoor.[22] The final cost of the church was £15,579. It has often been wrongly attributed to George Dance the Elder, who was a member of the vestry and who was buried there in 1768 – a black marble slab was provided by his children twenty years later, but has now gone.

The new church was consecrated in 1733 over a semi-subterranean crypt constructed of brick as an integral part of the church structure. This space was initially prohibited from use for burial, but this did not remain the case for long. The vestry minutes hold no mention of burial within the crypt below the church until 1740, when the fees are listed.

By 1810 the vaults were described in the vestry minutes as large and commodious, but dark, damp, neglected and highly offensive. Sufficient ventilation had not been secured and wooden coffins, rather than lead, had been admitted. The Vestry Committee

The church of St Luke Old Street, now LSO St Luke's, the UBS and LSO Music Education Centre.

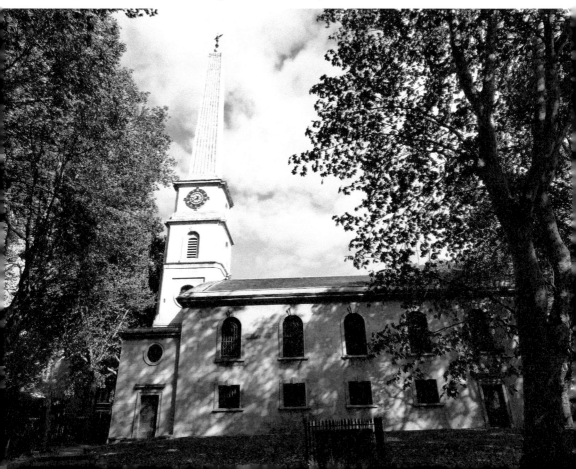

recommend that funerals of opulent inhabitants should be promoted in the vaults and churchyards; that the fees for interment in the vaults and churchyards should not be enhanced; that hereafter no corpse be permitted to be placed in the vaults, except in leaden or metal coffins; and that apertures of 3 feet in diameter should be made in the walls at the east and west ends of the church to ventilate the vaults.

The church suffered some war damage in the 1940s, which combined with the effect of heavy bombing on nearby sites, caused movement of the structure. The roof was removed in 1959 when some columns were seen to be hanging from the roof that they should have been supporting. The building was declared unsafe and the church abandoned.

A petition from the rector dated 27 November 1964 recorded that since the partial demolition of the nave, there had been the unlawful entry into the roofless precinct on many occasions by thieves and the homeless. While blocking windows and sealing openings in the brickwork, it was found that coffins had been disturbed, and in one instance the lead interior had been taken apart from the case and the top forced off to reveal the human remains in an advanced state of decay.

Stabilisation work was carried out in 1993–94 to prevent further damage. The conversion of the church into a music education centre began with the archaeological work in 2000.

Recording took place of the exhumation of burials in the northern and southern churchyards, the clearance of all burials in the crypt, funerary architecture and the crypt structure.[23] Between July and December 2000 a total of 1,016 burials were recorded, of which 335 individuals were named. The crypt comprised four west–east aligned barrel-vaulted bays built in red brick, with three spine walls, each one with three vaulted openings. There were twenty-one vaults within the crypt of St Luke's, containing a total of seventy-two burials, fifty-six of which were named individuals. Within the bays of the crypt beneath the church, much of the internal space of the crypt was divided off by brick walls or iron railings to create small rectangular private family vaults. A total of 712 coffins were recorded and removed during the work, comprising lead, wood, zinc and iron examples. These were all reinterred at Brookwood Cemetery, Surrey.

The newly reopened building preserved many of the original building features and now serves as a home for LSO's community and music education programme. The London Symphony Orchestra first played in the newly reconstructed building in January 2003. As well as LSO rehearsals it now plays host to a varied selection of concerts and has seen artists as diverse as Elton John, P. J. Harvey and Bruce Springsteen to the London Sinfonietta, Asian Music Circuit and Evelyn Glennie.

## St George in the East

St George in the East is another of the so-called 'fifty new churches' and was built between 1714 and 1726. The crypt, originally accessed from the south-west corner of the church, had been extensively used for burials, in a series of separate vaults. Corridors went around the perimeter, leading into separate chambers where coffins were stacked on shelves.

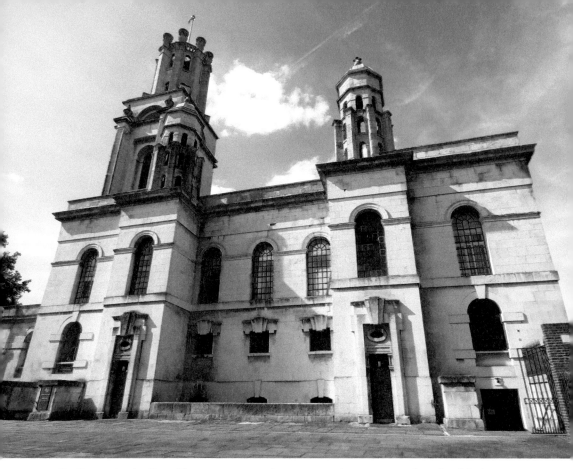

St George in the East. The entrances to the crypt can be seen at each end, with the nursery school entrance to the left.

The church and many of its surrounding buildings were gutted by fire during the bombings of the area in 1941, the church lying derelict until reconstruction began in the 1960s.

By 1960, the church had decided to clear and remodel the crypt; over 400 lead coffins from fifty-nine vaults were carefully removed and reburied at Brookwood Cemetery. The crypt then became a hall with a large stage, which was opened in 1964 as a music and drama centre as well as for parish functions. It was frequently used as a rehearsal and performance space by professional companies, including the Royal Shakespeare Company. It was also used for some pop music events, including the East End Sound contest in 1964. The final, won by The Walkers, attracted an audience of 650.

However, use of the hall (by both outside groups and the parish itself) declined and it needed considerable maintenance. In 2005 it was decided to convert the eastern (stage) end for the use of North Thames Ministerial Training Course, who remained there until 2012. The space was then temporarily used by Wapping High School while they waited for more permanent accommodation to be ready. In 2006 the parish adapted the rest of the crypt as a nursery school and it housed Green Gables Montessori Nursery School.

# St Paul's, Deptford

St Paul's, Deptford, was built to a design by Thomas Archer. It is constructed of Portland stone, as is the base on which it sits, and uses Headington stone stiffeners. The whole structure sits on a brick foundation. St Paul's was begun in 1713 and consecrated in June 1730.

Thomas Lucas of Deptford, who also built houses in nearby Albury Street, was responsible for the brick pillars and vaulted roof of the crypt. The commissioners particularly asked for Fulham sand to be used with the lime in the brickwork. A charge of 4*d* per yard was made for the digging of the crypt foundations, while the brickwork cost £5 per rod (16.5 feet).

In 1964 many coffins were moved to the four corners of the crypt and bricked in. The crypt was then adapted for use as a parish social club.

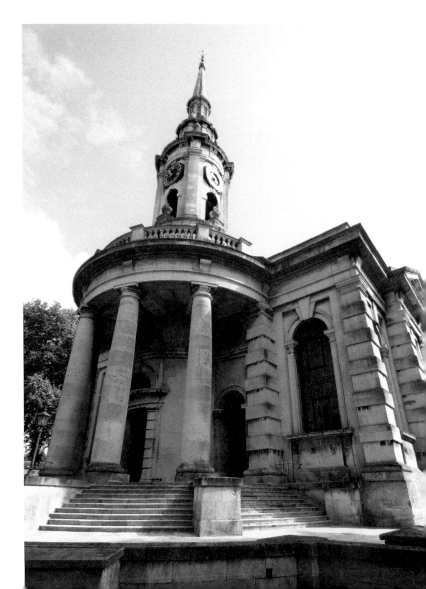

St Paul's, Deptford, consecrated in 1730.

The church was the subject of a Heritage Lottery Fund project and restoration took place between 1999 and 2005. With the help of the Thames Tideway Project, further restoration work is ongoing.

Twenty years ago, however, the crypt was apparently a damp, mildew-covered, run-down place with dirty walls, dirty floors and a questionable doorless toilet.[24] It was also a major subcultural centre. In the mid-1980s there was a regular Friday night psychedelic club. A flyer from 1985 noted the enticement to 'Be early – people are dying to get in'. The club was like an indoor festival featuring regular appearances from free festival favourites such as the Ozric Tentacles and the Magic Mushroom Band. Other bands who played there included TV Personalities, the Invisible Band, the Cardiacs, the Mighty Lemondrops, the Troggs, the Pink Faeries and the Shamen.

INSANITY

PRESENTS

HALLELUJAH

AT THE CRYPT
DEPTFORD SE8

SATURDAY
13 JULY 1991

FEATURING
DJ's
STEVE PROCTOR
ANDY NICHOLS.
SCOT SMITH,
+
GUEST.

INFORMATION: ALAN 0831-554016

A flyer for a club event in the crypt of St Paul's, Deptford, 1991.

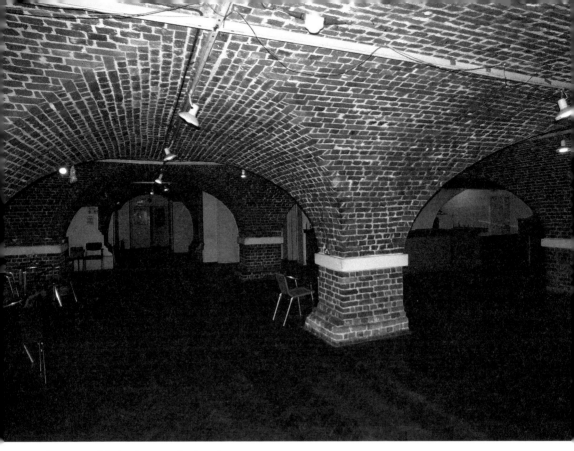

The crypt of St Paul's, Deptford, today.

The Band of Holy Joy played some of their first gigs at in the early 1980s at a club called the Stomach Pump in the crypt. Reggae sound systems also played in the crypt and there were punk gigs (anarcho-punks Virus played there in 1986), while in 1998 there was an early acid house club called Boomshanka on Saturday nights.[25]

## St Mary Woolnoth

One of the more unusual uses of a crypt is that of St Mary Woolnoth. The original church, which dated from 1191, was damaged by the Great Fire of London and was partially rebuilt by Christopher Wren in 1670–75. However, by 1712 a new building was required, which was built between 1716 and 1727 by Nicholas Hawksmoor, assisted by John James.

An 1891 letter from the rector at the time to the editor of *The Times* noted: 'Some years ago the smell from the vaults, which contain … the remains of 7 or 8,000 bodies, became so foul and offensive that we were obliged to discontinue the services.' The vestry then decided to seal the crypt with concrete, but this was not fully effective, as the rector commented that 'during the past summer, the church began to smell again, some of the congregation became ill, and I, after two and sometimes three services on Sunday, became affected with a sore throat. This smell at times was

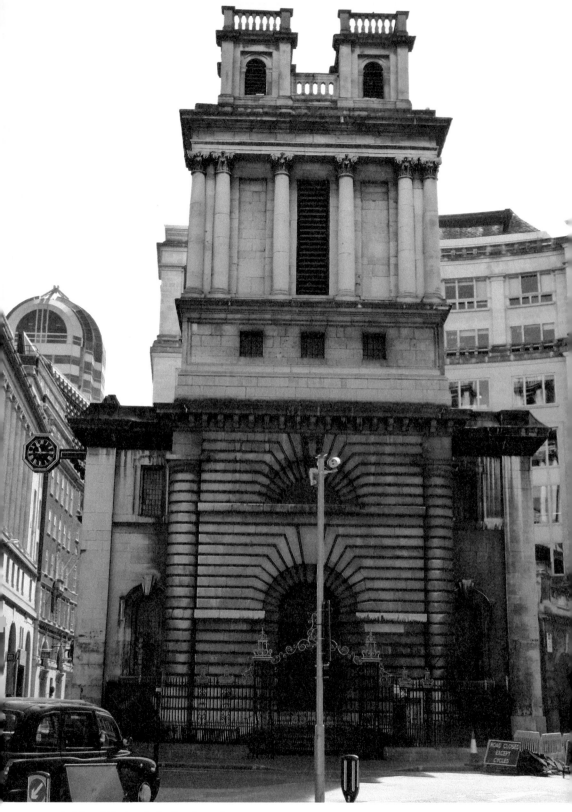

St Mary Woolnoth, by Bank station.

intolerable, coming up in whiffs and gusts'. He observed the following just prior to the removal of the contents of the vault:

> The mass of corrupted humanity contained within the four walls gives off an effluvium which must find a vent through the smallest of apertures, should such exist in the concrete. The fact that there are thousands of bodies within a foot or two of the floor of the church constitutes standing evidence of the insanitary condition. These bodies, from my own personal knowledge and sight, consist, roughly, of those which are dry and those which are wet. I should think that more than half are harmless, shrunken and withered, but the remainder are marvellously preserved flesh and bones, the stomachs nests of corruption, and here and there little pools of treacle reduced to such by catalytic process.[26]

Surprisingly enough, attendances for the services within the church dropped!

The entrance to Bank station, which cut through the crypt walls.

In 1897–98 plans were put in place by the City & South London Railway to demolish the church to allow for an entrance and ticket hall to what became Bank station. However, there was a public outcry against the demolition, so a new plan was devised and the church was spared. Access to the station from street level was now to be from a shaft dug through the church foundations and the crypt, which now forms part of the station, the church having been underpinned with steel girders. Part of the crypt ceiling can still be seen when the King William Street entrance is open. All the burials were removed and transferred to City of London Cemetery, Ilford, at this date.

## St George the Martyr, Southwark

This church was rebuilt between 1734 and 1736, partly funded by £6,000 from the Commission. The vaults below the church were used for interment in the eighteenth and nineteenth centuries. Clearance of coffins from the central crypt area and satellite vaults occurred during the Second World War, with the remains taken to Brookwood Cemetery, near Woking.

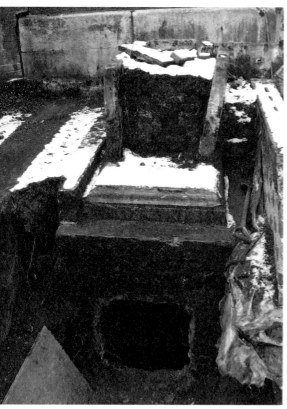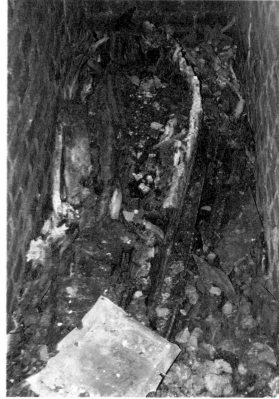

The above left and right ground remains of a family vault recorded in the churchyard to the rear of St George the Martyr, Southwark. (© MOLA)

The earliest reference to this church is in the annals of Bermondsey Abbey in 1122. The west tower dominates views along Borough High Street. In 1750, Tabard Street was extended through the churchyard on the north side of the church, leaving the church on an island site. A report dating from 1841 notes of the vault:

> Clergymen … have been obliged to stay a certain distance from the grave in open grounds, or to stand at the top of the stairs of a vault to read the burial service, as at St. George's Church, Southwark; where for many years the clergyman dared not venture into the vault, and where the undertakers were compelled to use the most indecent haste in taking the mourners down and bringing them up again to prevent danger.[27]

The nave was declared unsafe in 2000, and in September 2000 the floor levels in the crypt were lowered to create additional space. A large number of lead Georgian coffins were removed from the crypt to allow the works to take place. Subsequent archaeological investigations of the ground beneath the church found substantial medieval and Roman structures. As part of this work, the rear of the church was also affected, allowing the recording of a family vault in the churchyard.[28]

CHAPTER SIX

# Later Churches

## St Pancras New Church

St Pancras New Church was built on Euston Road between 1819 and 1822, as the population of the southern part of the parish had increased. It was built by Isaac Seabrook to the designs of architect William Inwood and in collaboration with his son, Henry William Inwood. At the time of its construction it was the most expensive

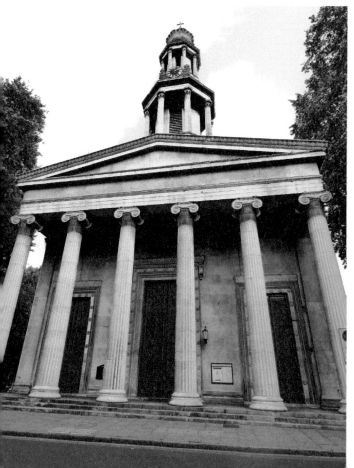

St Pancras New Church,
Euston Road.

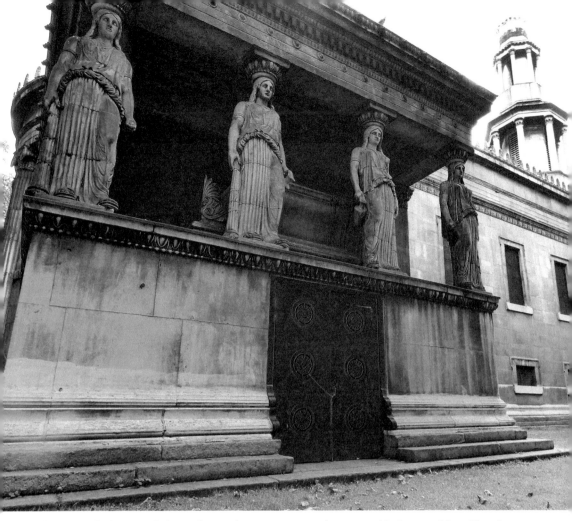

The caryatids that stand above the northern entrance to the crypt of St Pancras New Church.

church to be built in London. It is notable for the two sets of caryatids that stand above the north and south entrances to the crypt, modelled on those on the Acropolis in Athens, produced by the sculptor John Charles Felix Rossi.

A small-scale archaeological evaluation was undertaken in 1995, which looked at six of the twenty-nine vaults. The condition of coffins and other types of material culture seen within both the half vaults and full vaults (with and without air vents) appeared to be very good. These broad types of vault comprise twenty-five of the twenty-nine burial areas.[29]

The crypt, fully protected as an integral part of the listed building, is of considerable architectural interest in form, building materials and construction technique. The crypt is built mainly of good-quality yellow stock bricks, with stone footings and dressings, especially in the area under the tower and west portico. In plan, it reflects the arrangement of the spaces above, notably the position of the cast-iron columns supporting galleries on both sides of the nave rather than the windows in the north and south walls. The passages and burial spaces in the crypt are generally tunnel-vaulted in brick with simple groins where they meet. The floor is partly paved with brick, taken

up in places to expose sterile pebbly earth. Forty vault spaces exist, of which nineteen have been filled and sealed, generally by being bricked up, while ten others have been half-filled and sealed with plaster. A central space under the apse contains two brick tomb chests. Several vault spaces have been railed off, before being partly bricked up. Two of the vault spaces opposite each other in the centre of the crypt have been used as a cross-passage, in addition to intended passages at the east and west ends.

In 2002 the crypt at St Pancras New Church became a gallery space where the imagination, thoughts and emotions of twenty-first-century artists are shared with visitors from around the world. Now this popular venue hosts a year-round programme of art exhibitions

# Holy Trinity Church, Marylebone Road

Holy Trinity Church, situated on Marylebone Road opposite Great Portland Street, was built in 1826–28 to the designs of Sir John Soane to celebrate the defeat of Napoleon. It was an improved version of his earlier St Peter's, Walworth, and was consecrated on 31 May 1828.

The definitive work on London's burial grounds, Mrs Basil Holmes's 1895 survey for the London County Council, was published in 1896 as 'The London Burial Grounds'. This records that the vaults below the church were used for burial, but that no burials took place in the area surrounding the church and that there was no other graveyard attached.

The parish burial registers for Holy Trinity show that burials did take place in the crypt between 1829 and 1853.The first burial, that of Mary Poyyer of No. 7 Charlotte Street, Fitzroy Square, took place on 15 September 1829, while the final interment took place on 7 January 1853. This was that of Baronet Sir Jonathan Wathen Waller of New Cavendish Street, who was an 'oculist' (optician) to George III and Groom of the Bed Chamber to William IV. Between these dates a further ninety-three burials took place. All of these burials have been moved from the crypt, but it is not known when.

In 1936, Allen Lane resigned from publishers the Bodley Head and founded Penguin Books. Lane's new offices were in the crypt of Holy Trinity Church, which had previously been used as a store by the Bodley Head. In 1937, Penguin moved out of its office in the crypt to a 3.5-acre plot at Harmondsworth, Middlesex. The property cost £2,000, plus an additional £200 for the crop of cabbages already planted on the land.

The chancel was added in 1876. The building was converted in 1956 by Handisyde and Taylor into the SPCK (Society for Promoting Christian Knowledge) offices, who remained there until 2006. It is now a venue offering a range of events from Christmas parties, exhibition space, charity and corporate events, engagement parties and weddings.

Since November 2017 the crypt itself is now the Wedding Gallery, described in their publicity as 'the world's first luxury wedding store for shopping, wedding planning and inspiration'.

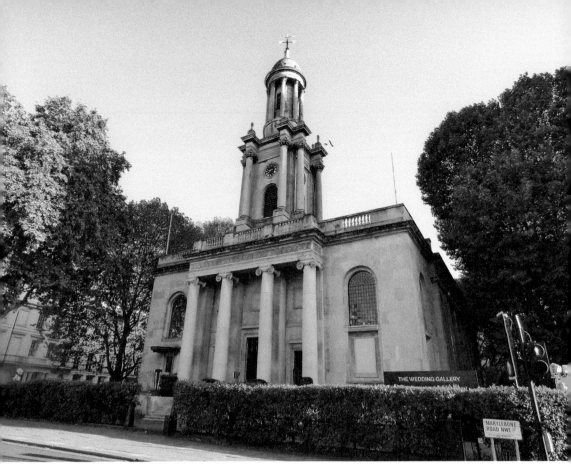

The former Holy Trinity Church, Marylebone Road, now an events location and home to the Wedding Gallery.

## St Mary Magdalene Church, Holloway Road

The Act for the construction of a chapel of ease and an additional burial ground for the parish of St Mary Islington was passed in 1811. St Mary Magdalene did not become a separate parish church until 1894.

Below the east end of the church are three vaults, one in the centre and two to the north. The northern one is divided into two sections by an arched entrance. The main entrance to this vault has an iron gate with a wooden door behind, which seems to have been added later to screen the coffins. The western section of the north east vault contains around forty coffins, all well preserved, while the second vault to the rear seems to be fuller. The central vault at the east end of the church has been bricked up but contains at least three well-preserved coffins.

At the west end of the church two boarded partitions, one with a door, have been inserted in the main vaults to block access to the two small vaults at that end. The one of these with a door apparently contains headstones, while the other vault is that of the Barclay family.

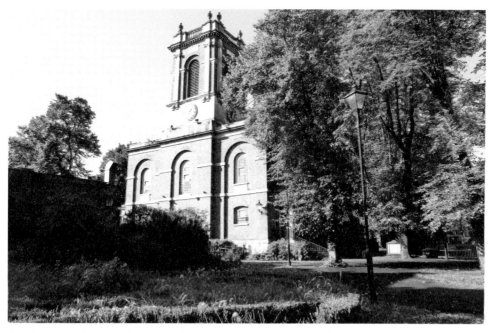

St Mary Magdalene Church, Holloway Road, originally built as an additional chapel for St Mary's Church, Islington.

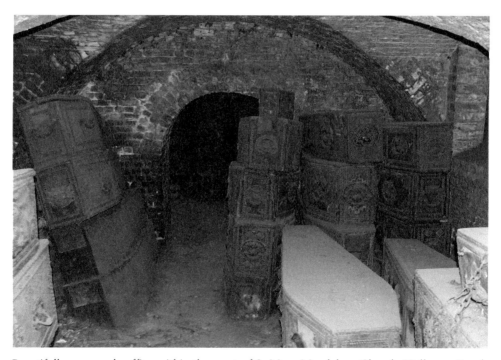

Beautifully preserved coffins within the crypt of St Mary Magdalene Church, Holloway Road. The fabric covering and all the decorative coffin furniture survived intact after the crypt was sealed in the 1850s.

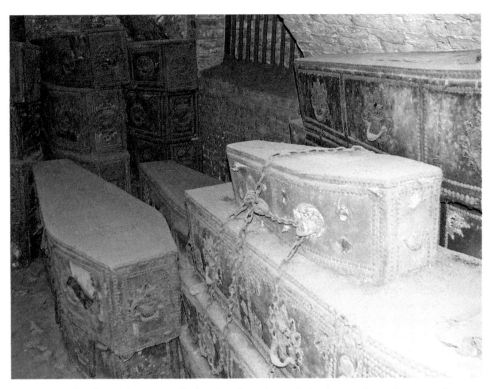

This stack of coffins – from a single family – have been chained up to keep them together.

# New Bunhill Fields

George Walker, a well-known Victorian campaigner against burial within populated areas, records how many of the burial vaults were not pleasant places. The ground known as New Bunhill Fields in Southwark is one such example:

> This burying ground is situated in the New Kent Road; it is a private speculation, and belongs to Mr. Martin, an undertaker. It has many attractions for survivors; the fees are low, the grounds are walled round and well watched, and the superintendent of the place resides upon the spot. At the entrance of the ground a chapel has been erected; it belongs to the Wesleyan connexion; under this chapel, arched with strong brick-work, is a spacious vault, containing about eighteen hundred coffins. There are not more, I believe, than twelve bodies placed in lead out of the entire number. Iron gratings are placed on each side of the vault, and its entrance is by steps, through rather an extensive doorway. It appears that the original proprietor of the place was named Hoole. Two coffins, one containing his remains, and the other, stated to contain the remains of his daughter, are placed in the bottom of the vault, at the upper end, on the left-hand side of it, enclosed with iron railings ...
>
> A strong ammoniacal odour pervades this vault; it is not so offensive as that which I have experienced in most other depositories of this description; this I attribute,

to the constant transmission of the noxious vapours, (through open iron gratings) to the circumambient atmosphere. The burial ground and vault, it appears, have been employed, for the purposes of interment, about eighteen years, during which, not less than ten thousand bodies have been inhumed and deposited, within this 'narrow spot of earth', and the vault connected with it. Yet, around this tainted atmosphere, many houses are erected and boards are placed offering ground to be let upon building leases!

Haycock (who was the grave digger for the burial ground and the chapel) stated that at one-time bodies were stacked in the vault at the rate of £1 each for 6 months … what becomes of them after the expiration of the 6 months tenancy he does not say.

The ways of the wicked, however, are not always prosperous, and a just providence sometimes demonstrates his wrath by nature of the punishment which overtakes the guilty. This same Hoole … fell victim to his beastly occupation. A report appeared in a morning paper that 'his vault was over the shoes in human corruption'. The fear of the press inspired him with a sudden desire to set his house in order; he came in from the country, worked in his shirtsleeves at the piles of decaying matter heaped up in the vault, went home ill, and together with his 'head man' died in a few days. So may the unrighteous perish!

Haycock, who died of consumption about 9 months ago, told me some years since that 'the stench in digging graves in that ground was horrible'; that he had frequently scrambled out of the hole he was making, – that his eyes struck fire, – his brain seemed in a whirl, and that he vomited large quantities of blood.

Haycock, although an exceedingly strong man when he commenced grave digging, offers another evidence, amongst too many others, of the power of emanations from the dead over the health of the living. I knew him and attended him occasionally, during many years. I saw him droop, die inch by inch; and although the disease was held under control during a short period, his life paid the forfeit.[30]

## St Mary-at-Lambeth

There has been a church on the site for centuries. The present one was rebuilt in 1851–52, with some parts of the medieval structure surviving. In 1972 the church was made redundant due to its rundown state and a shift in the population. The vicar wanted a church closer to where the congregation lived, thus in 1969 Lambeth Council designated the area around Lambeth Palace as one of the borough's first conservation areas. The Church Commissioners obtained the necessary consents for demolition, and the altar, bells and pews were removed. A trust was created in 1976 that rescued and repaired the church, converting it into the Museum of Garden History – now the Garden Museum.

The Archiepiscopal Burial Vault is directly beneath the altar in the sanctuary of St Mary-at-Lambeth. The vestry minutes and churchwardens' accounts suggest a construction date of *c.* 1711. This came to light during refurbishment of the museum

during 2016–17. The vault contains thirty-three coffins, spanning the years 1715 to 1838. The most notable find within this vault was an archbishop's gold-painted funerary mitre on top of one of the coffins. There are four Archbishops of Canterbury that lie within the vault: Archbishop Thomas Tenison, Archbishop Matthew Hutton, Archbishop Frederick Cornwallis and Archbishop John Moore. The vault has been left undisturbed and visitors to the Garden Museum will be able to view it through a glass floor panel.

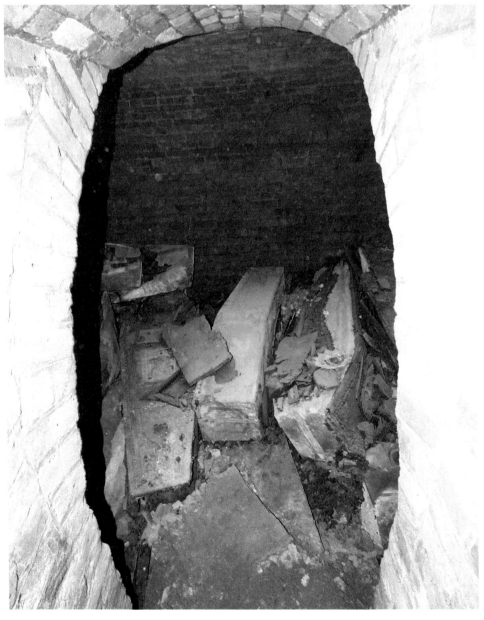

View of the Archbishops' Vault from the base of the entrance steps.

St Mary-at-Lambeth, now the home of the Garden Museum.

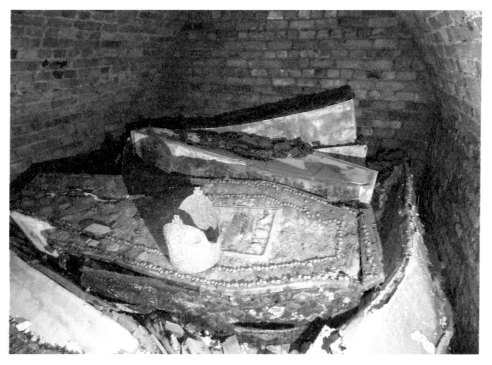

Looking into the Archbishops' Vault – the mitre is clearly visible.

# St John's Church, Wapping

By 1756 the original St John's, Wapping, had become virtually unusable for worship as it had been built on a particularly swampy part of the reclaimed marsh. Water was encroaching on both the church itself and in burials in the graveyard. A new church was built across Cock Alley on the site area, designed by Joel Johnson. The old one was demolished and the site was used as an additional burial ground.

It was hit by incendiary bombs in 1940 and, although the tower was left standing and restored by GLC Historic Building Department in the 1950s, the nave walls were subsequently taken down for safety reasons.

The churchyard was divided into three areas: a communal burial vault directly up against the wall of the church containing forty-one separate coffins; a series of ten family burial vaults along the southern boundary wall of the site, which held forty-four in total; and the remainder of the burial area, containing around 345 individuals.[31]

This contained forty-one individual burials that could be identified from the surviving coffin plates, dated between 1750 and 1852. Most of the coffins were lead and were usually stacked on top of one another – up to three high. There had clearly been some moving of coffins within the vault or from a different burial location, as earlier coffins had been placed on top of later burials. Some disturbance of burials

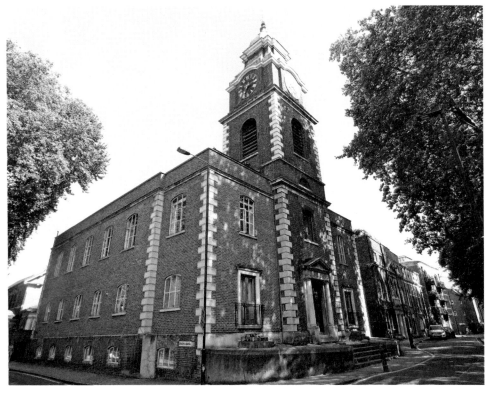

St John's Church, Wapping.

within the vault had also taken place as all the corners of the structure contained a collection of disturbed bones.

A total of 313 burials were cleared from the crypt below the church in 1995 by the Necropolis Company. A limited record of each burial was made, the name and age of the individual being recorded along with location and material of coffin. A vault plan was drawn and a number of general photographs of the clearance were taken. The crypt contained thirty-four separate vaults, of which all but two appear to have been family vaults. The vaults appear to have been secured by individual families by 1820 and burials continued in them until 1853.

Despite some vandalism recently and in the 1950s, the burials were in good order and were still stacked – mainly in high-quality coffins. In one vault, however, the coffins had been haphazardly placed and the vault filled with soil contained many oyster shells. The infill was sealed by a layer of charcoal. The date of the coffins in this vault suggests it may have been a result of tidying the vault when burial ceased in 1853.

The two earliest coffins in the crypt – a husband and wife – date from before the crypt's construction, suggesting transfer from the earlier church.

# St Marylebone Parish Church

The discussions about building a new church for St Marylebone began in 1770, when the vestry obtained the power to borrow £20,000 and advertised for plans for a church seating 1,200–1,500 people at a cost of £15,000. In April 1770 the bill for 'Building a new church, for making a cemetery or churchyard, for making the old church a chapel and for building an house for the Minister', which was to be presented to the House of Commons, was read to the vestry. Plans were submitted by William Chambers, Gandon and Woolfe, Charles Little, John Johnson and John White. No decision was forthcoming. By 1778 the Duke of Portland had offered a site and a variety of options for location were considered, but again no decision was made. The vestry's wretched performance was much criticised. They were faced with the Crown, the Duke of Portland and Mr Henry Portman all wanting the new church to be on their land for prestige and so that their part of Marylebone would benefit. To accept one would antagonise the other two. The Duke of Portland died in 1809 and the vestry once more addressed the issue, by which time the projected cost had risen to £50,000. The new duke finally gave the land, and the foundation was laid in July 1813. By the time St Marylebone Church on Marylebone Road was completed, having been extended during the building process, it had cost £62,000. It was consecrated in 1817.[32]

The crypt was cleared of burials during 1983, with some 850 coffins being removed to Brookwood Cemetery in Surrey. No archaeological record was made of this clearance, but a list of those reinterred is held in the St Marylebone parish office. This list contains 596 entries, of which 528 have names. The coffin plates recovered during the clearance were subsequently acquired by the University of Reading Department of Typography and Graphic Communication. These were recorded in September 2013

*Above*: St Marylebone Church from the church gardens on Marylebone High Street.

*Right*: The brass coffin plate of the Right Honourable John Viscount Kelburne from the crypt of St Marylebone. (© MOLA)

by archaeologists from MOLA to help create a full database of the coffin plates, including the biographical information they contained and the details of the plate types, styles and decoration.[33]

Following the emptying of the crypt, the space was converted to be used as the Marylebone Health Centre (NHS), the St Marylebone Healing & Counselling Centre and the Guild of Health.

## St Martin-in-the-Fields

The present church was erected from the designs of James Gibbs. The foundation stone was laid on 19 March 1722 and the building was completed in December 1724.

The burial ground was located where the National Gallery now stands and contained approximately 70,000 bodies. The loss of much of the main churchyard led to a scheme to excavate the remainder of the churchyard and construct burial vaults around 1830. These occupied virtually the whole of the remaining east and north churchyard. They included pavement vaults beneath Duncannon Street and part of the northern alleyway (between St Martin's Lane and Adelaide Street).

These catacombs were opened in 1830, but were closed again in 1853, in which time a total of 3,250 coffins had been interred. In 1859, the vaults were to be closed and human remains were again removed from the site, either to Camden Town or the London Necropolis Cemetery at Brookwood, Woking. Friends and relatives were given until 1 February 1859 to remove coffins.

The naturalist Frank Buckland describes how he went to the church to try to locate the body of the surgeon John Hunter, buried in Vault 3. He told of opening the oak gate of the vault to see a room filled from floor to ceiling with coffins in complete disorder. These coffins were all lead covered, but in the adjoining vault were wooden coffins. He writes that 'the faint and sickly effluvia which emanated from these vaults was truly overpowering and poisonous'. He worked for fifteen days reading the name plates as the coffins were removed, until finally it was discovered. The lead coffin was burst from the decomposition within and the upper lid loosened. Several members of the Council of the Royal College of Surgeons came to view the coffin, but no attempt was made to inspect the contents either by them or by Buckland. The total number of coffins interred in this insanitary manner in the vaults of St Martin-in-the-Fields was no less than 3,260.[34]

The crypt was converted into a café some time ago, with the new entrance having been added during restoration work carried out from 2001 to 2007.

The crypt was used as a homeless shelter in the 1930s, with up to 140 people sleeping there every night. 'One side room … housed 44 bunks reserved for women. Queen Mary paid a visit in 1933 and was particularly taken with the "children's corner", a disused vault now turned into a tiny chapel where children read and pray every day.' The crypt was also used to billet soldiers during the two world wars. Part of the space was turned into a club for troops in the 1940s, complete with dartboard and ping pong. It has also served as a dance hall, exhibition space and a branch of the Citizens Advice Bureau.[35]

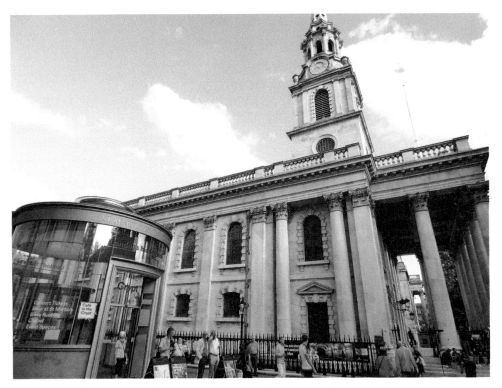

St Martin-in-the-Fields, with the new entrance to the crypt café.

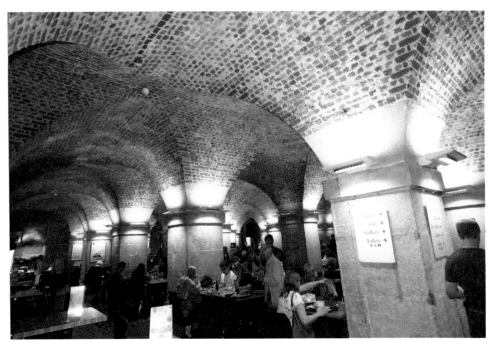

Café in the Crypt, below St Martin-in-the-Fields.

CHAPTER SEVEN

# Catacombs

## Friends Movement

The survival and protection of many of the large Victorian cemeteries in London is largely down to the various groups of 'Cemetery Friends' who have been established with preservation in mind. They also aim to promote the conservation and appreciation of the cemeteries as places of remembrance, of historic importance and of natural beauty. Anyone with an interest in the subject should consider joining

The annual open day at Brompton Cemetery. This is usually held in July, with a selection of guided tours of the cemetery on offer throughout the day.

one of these groups, as well as supporting them by attending one of their open days. These are often the only way that access to the catacombs can be gained, and these are usually fascinating guided tours of other sections of the cemeteries led by experts in their field. Links can be found at the end of this book.

Nunhead Cemetery had been left to fall into decay when the owning company ceased trading and it was threatened with development. In 1981, the Friends of Nunhead Cemetery (FONC) was founded following the acquisition of the cemetery by Southwark Council for £1 in 1975.

The Friends of Kensal Green Cemetery were established in 1989 to help stimulate concern and interest for the long-term conservation of the cemetery. Much work has been done by the Friends to raise the profile of the cemetery as a place to visit and it organises regular guided tours. The Friends took the lead in restoring the Dissenters' Chapel in 1997 with the Historic Chapels Trust, assisted by grants from the council, English Heritage and the Heritage Lottery Fund. The chapel is now the home of the Friends of Kensal Green Cemetery.

The Friends of West Norwood Cemetery was established in 1989 to try to prevent Lambeth Council from clearing historic monuments from the cemetery. Following the compulsory purchase of the cemetery from the South Metropolitan Cemetery Company in 1965, the council removed some 15,000 gravestones with the original aim of creating a memorial park. Today, Lambeth Council is working with the Friends to restore and improve Norwood Cemetery.

The Friends of Brompton Cemetery have been involved in the restoration and preservation of the cemetery, including the renovations of the lodges by the Old Brompton Road entrance. Their offices and new meeting rooms are in the restored North Lodge.

## West Norwood

West Norwood Cemetery was founded in 1837 as the South Metropolitan Cemetery and laid out to the design of William Tite. It contained both an Anglican and a dissenter's chapel, the latter of which became one of the first crematoriums in 1915. Both of the chapels were described in 1840 as 'light and elegant examples of Gothic architecture and both had cloisters stretching out at right angles from each of their sides'.[36]

A private vault in the catacombs to hold one coffin could be had for £14 or £17 for 'extra size'. This rose to £132 for a vault to hold twelve coffins, while the same sized vault with 'extra size' would hold nine coffins for £129.[37]

Catacombs were constructed under the Anglican Chapel, which included ninety-five vaults with a capacity of roughly 2,500 coffins. They were constructed from brick and had vaulted ceilings, originally with circular light openings in the ceiling. Most of the vaults within have shelves, either made from iron or stone. The last coffins were interred in the 1930s. The catacombs comprise a central gallery with six corridors running off it, three on each side. Each of these corridors contained seven vaults on each side, with a further eleven in the central corridor. In the centre of the main corridor is a hydraulic coffin lift, known as a catafalque, designed by Bramah & Robinson,

dated 1839, which dominates the main hall. This was designed to lower the coffins slowly and quietly from the chapel above to the vaults below. Access to the catacombs was originally from a staircase coming down from the chapel, but is now gained using an external staircase towards the east end.[38]

Both chapels were extensively damaged during the Second World War and were later demolished, the Dissenters' in 1955 and the Anglican in 1960. A new crematorium replaced the original in 1960, with the new furnaces housed in the surviving catacombs, which had never been very popular. After the chapel was demolished in 1960 the catacombs were sealed and the site was marked by brick walls enclosing a garden of remembrance with lawns and rose beds. Today, this is fenced off and the whole area is covered with a scaffold roof to prevent further damage to the structure below ground and its contents.

A staircase, now closed off, leads down from the chapel, and at the end of each side corridor is an air vent to allow airflow through the catacombs. The six narrow-vaulted corridors are lined with stone shelving (loculi) on which the coffins are laid. The coffins are, as required for above-ground burials, lined with lead. There are around 2,500 coffins in the West Norwood catacombs, with room for many more. Some bays contain gated vaults or are individual, with either cast-iron gates or stone memorial tablets; others were left open.

The West Norwood Crematorium. The South Metropolitan Cemetery at Norwood was purchased by the London Borough of Lambeth in 1965 and renamed West Norwood Cemetery.

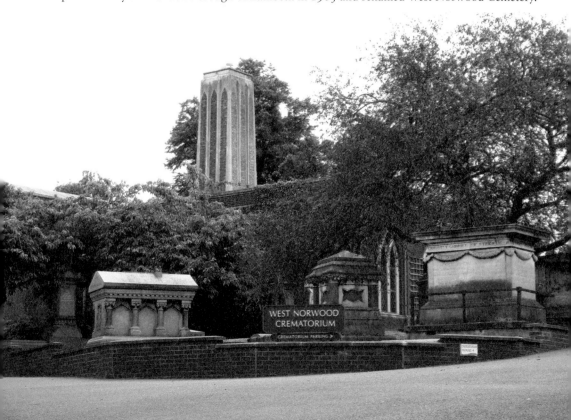

The rose garden was constructed over the Anglican catacombs at Norwood cemetery following demolition of the chapel. The below-ground structure and contents are now protected by the scaffolded roof.

The external entrance to the Anglican catacombs. The catacombs in West Norwood are sometimes available to visit via the Friends of West Norwood Cemetery tours.

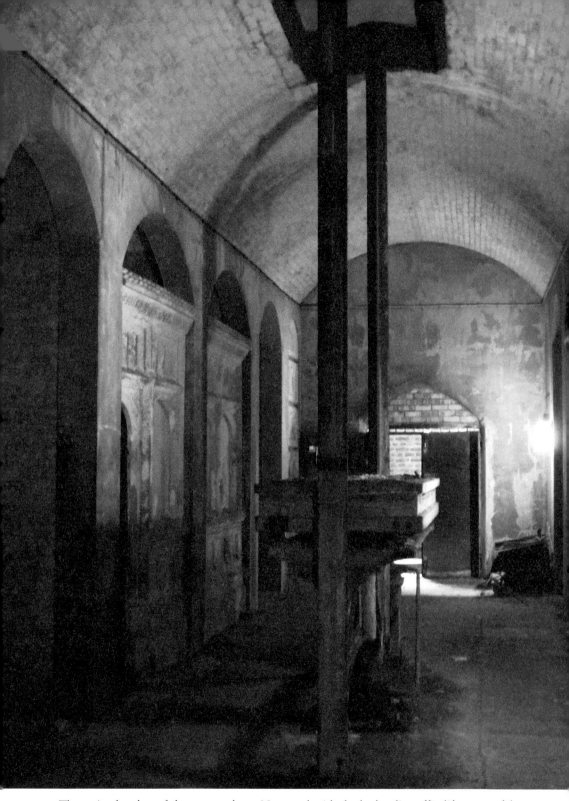

The main chamber of the catacombs at Norwood with the hydraulic coffin lift, or catafalque, in the centre.

The lifting mechanism of catafalque, designed by Bramah & Robinson, dated 1839.

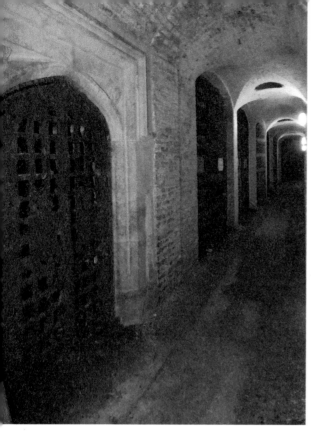

*Left*: The vaults along the central chamber within the catacombs.

*Below*: One of the bays within the catacombs. This one has coffins on stone shelves and has not been sealed in.

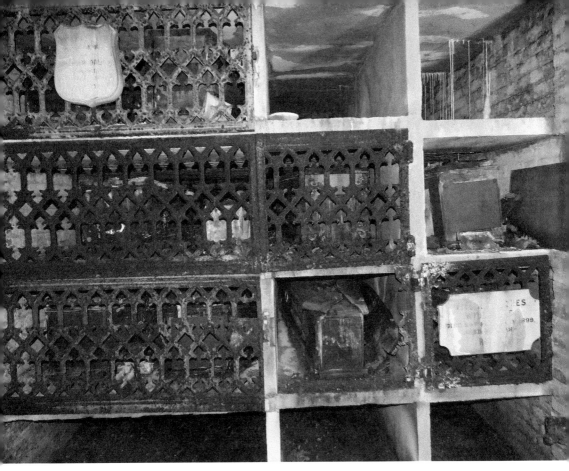

Individual loculi within one of the bays. These are both double and single widths in the same bays. Some of these have been closed off with iron traceries.

Media companies have occasionally used the catacombs for location filming. One of the most unusual uses of a set of catacombs came to light in October 1987, as reported by Associated Press:

After a three-month surveillance operation, police arrested two men after one of them was seen receiving a package outside West Norwood cemetery. The man sped away on a motorcycle but was stopped two miles away by police, who found 6.6 pounds of cocaine on him. More of the drug was found at the 42-acre cemetery. The two men, 31-year-old Ian Berry, the cemetery foreman, and 38-year-old Edward Coakley were charged with possessing about 90 pounds of cocaine. Police said they believe the drug ring smuggled the cocaine into Britain from South America and Spain. Detective Chief Superintendent Roy Penrose, head of Scotland Yard's Central Drugs Squad, inspected the 150-year-old catacombs. He said an alcove there had been used to store a large amount of cocaine but stressed that the traffickers had not damaged or disturbed any of the lead-lined coffins that lie inside the labyrinth of underground corridors. 'There are such a number of tunnels and small alcoves that it would have been easy to hide things without damaging or desecrating anything,' said Penrose.[39]

# Nunhead

Nunhead Cemetery was established by the London Cemetery Company and consecrated in 1840. It was intended to create a park-like garden with wide lawns, winding paths and tree-lined avenues. The design took advantage of the natural slopes of Nunhead Hill to provide stunning views across central London and away to the North Downs. By 1850 it had become the fashionable place to be buried for the wealthy of the region.

After the First World War, the fortunes of the London Cemetery Company began to slowly change, due to changing burial fashions and the ever-increasing cost of maintenance. During the Second World War the cemetery suffered greatly from bomb damage, labour shortages and the removal of iron railings from the boundary walls to assist the war effort. The London Cemetery Company retained shares on the stock exchange up until the 1960s, but in 1969 the company ceased trading at Nunhead; the gates of the cemetery were closed and the grounds fell in to disuse. The undergrowth took over much of the site and the monuments and buildings fell victim to both decay and vandalism.[40]

Following the threat of the site being redeveloped in the 1970s, the Friends of Nunhead Cemetery were formed to help protect the site. Southwark Council acquired the site in 1975 for the nominal fee of £1.

Much of Nunhead Cemetery has reverted to the wild, masking the locations of the demolished shaft catacombs.

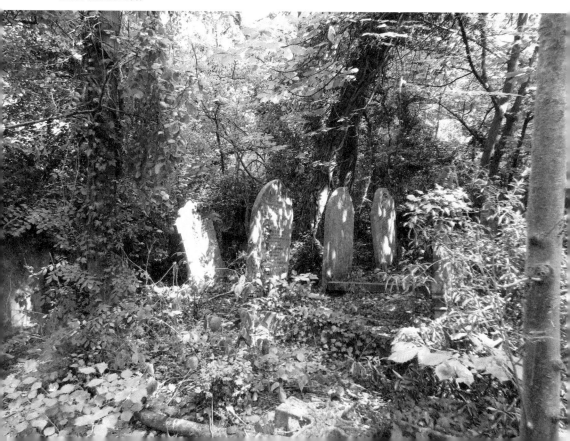

The Anglican Chapel and the crypt under it were constructed in 1844 in a dominant position at the top of the central path. The crypt was accessed through an entrance to the rear, although a hole in the chapel floor may have been intended to lower coffins into position. It is not known if this was ever actually used for this purpose.

The crypt contained seventy-six cells, each to hold a single coffin. Fifty-two of these were to the side, with the remaining twenty-four to the rear – known as the Central Compartments.

The first burial in the crypt took place in 1848 and it was in use through to the final interment in 1906. By that date the fashion for crypt burial had declined and there had been plenty of available space, with thirty-two of the cells never having been used. The chapel continued to be used for funeral services up to 1968. Following the closure of the cemetery, the crypt was subject to repeated bouts of vandalism, before the chapel was seriously damaged by fire in 1974. Following Southwark Council taking over the site it was boarded up to prevent further access and damage, while the undercroft was sealed. It remained closed until 2000, when a grant from the Heritage Lottery Fund allowed the chapel to be renovated and the crypt restored. New doors that matched the originals were installed and twenty-nine new coffins were made to replace those that had been damaged or destroyed.

The Dissenters' Chapel also had catacombs below, although only four interments took place there. This building was damaged beyond repair during Second World War bombing and was demolished around 1951.

There were originally a total of five other sets of catacombs at Nunhead. Four shaft catacombs were constructed by the cemetery company and can already be seen on an 1841 plan of the area. The two easternmost of these seem never to have been used and were demolished in 1890 and 1898 by the cemetery company and replaced with other graves. The two other shaft catacombs were lightly used, with a total of only nine interments having taken place in them. The western one was located behind the Scottish Martyrs' Memorial, but was demolished and today there is nothing remaining to be seen above ground. The fourth of these, to the east of the entrance to the cemetery, survived until the 1970s when it was surveyed for Southwark Council. They found to be structurally unsafe, so the entrance was demolished, the coffins removed and the chamber backfilled.

The Eastern catacomb probably dates to the opening of the cemetery and survived until 1976. It was a brick-built, barrel-vaulted structure containing 144 burial spaces, arranged in twelve vaults containing twelve cells. It also had a series of nine family and public vaults on either side of the central passage. As with the other Nunhead catacombs, it still had space for further burials at the time of its effective closure in 1904. In the 1930s a collection of remains from the former churchyard of St Christopher-le-Stocks were transferred to this catacomb, where earlier disturbed remains from the churchyard had been placed in 1867.[41]

Sadly, this catacomb was also subject to vandalism in the 1970s and, following Southwark Council taking over the cemetery, it was also sealed to prevent access.

*Above*: All that can still be seen of the eastern catacombs at Nunhead Cemetery.

*Below*: The Anglican chapel at Nunhead.

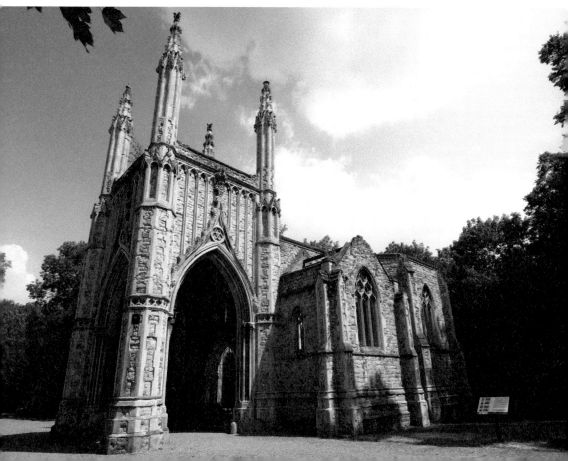

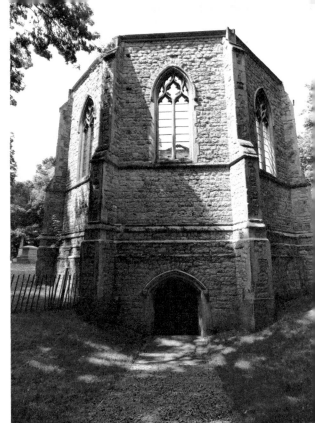

*Right*: The entrance to the crypt at the rear of the Anglican chapel.

*Below*: The crypt catacombs at Nunhead. As can be seen, most of the shelf spaces are empty, the coffins having been moved.

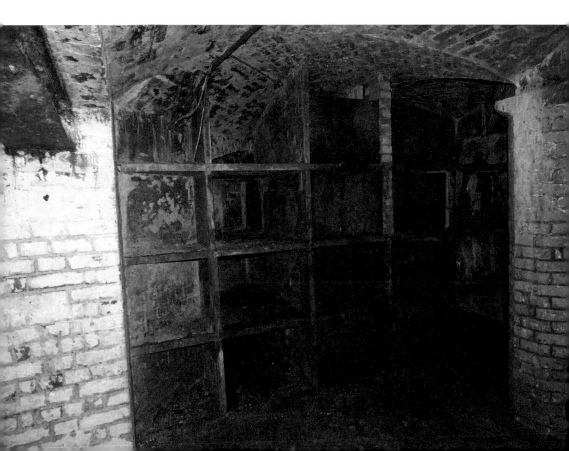

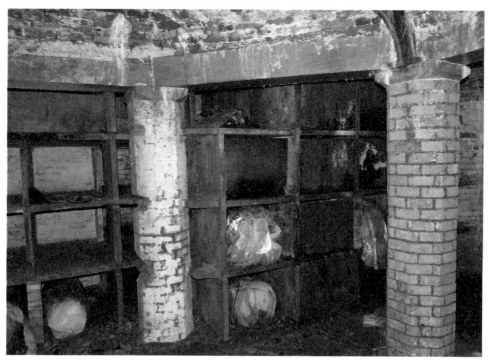

The coffins within the cells have been wrapped in plastic to prevent further damage.

The majority of the space below the chapel was not actually used for interments. Some memorial plaques can be seen against the right-hand wall.

# Brompton Cemetery

The West London & Westminster Cemetery Company was set up in 1837 to lay out a new cemetery in Brompton to the east of the Kensington Canal. The cemetery was consecrated in June 1840, the first burial taking place a few weeks later.

Overall Brompton was not a success, with the initial number of burials being disappointingly small for the company. This eventually led to the cemetery being taken over by the government department of the Commissioners of Works and Public Buildings in 1852.

The cemetery is centred around the Colonnades, two parallel arcades leading to the Great Circle, with two more arcades leading up to the chapel, designed by Benjamin Baud.[42]

Catacombs were constructed underneath the arcades, which are accessed by a series of flights of stairs down towards cast-iron gates. Despite there being space for thousands of coffins in the main catacombs, only around 500 interments took place and much of the structure is empty. They were constructed so that a space capable of containing six coffins could be enclosed as a private mausoleum.

The fees to be buried in the catacombs varied depending on location. The western catacombs rates went from £12 for a single coffin up to £115 for the space for twelve coffins. These were cheaper than those below the Great Circle, which started at £15 for a single coffin and went up to £200 for the space to inter twenty coffins. A fee was payable for each interment of £5 5s for each adult and £3 10s for each child.[43]

The Grand Circle at Brompton Cemetery. The catacombs are located beneath the colonnades.

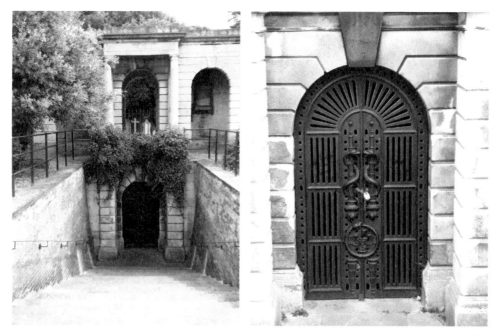

*Above left and right*: The steps down to the catacombs, with the cast-iron doors. Note the snake and inverted torch motifs, which represent eternal life.

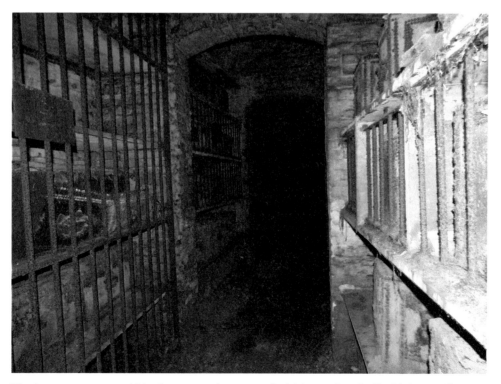

The interment spaces within the catacombs, some of which are closed off with iron grilles.

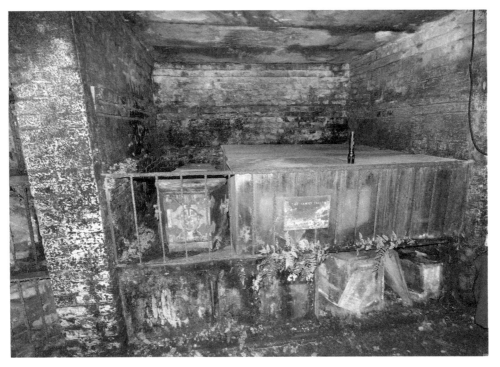

A family vault just inside the catacombs at Brompton.

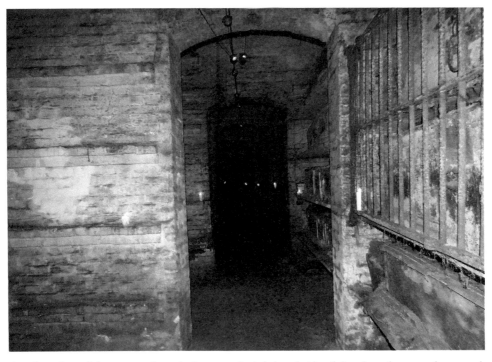

Another view of the catacombs – the bays on the left-hand side of the photo have not been used.

A second set of catacombs were built along the entire length of the western boundary wall of the cemetery. These were intended to have a raised promenade above them to provide views over the canal and fields. However, serious faults were found with this structure as early as 1843 and the draining of the canal to allow for the construction of the District Line by 1871 led to large sections of the promenade being taken down. Today, stretches of the western catacombs have been removed, with less than half having survived the damage caused by structural problems and bombing in the Second World War.

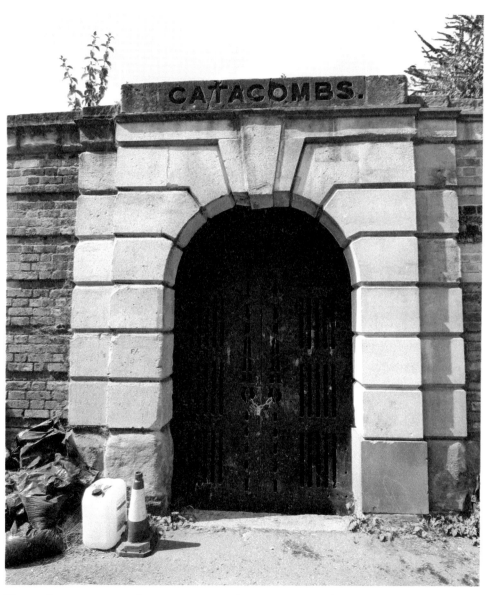

The northern entrance to the western catacombs at Brompton. This is now separated from the rest of the western range following wartime damage.

The southern entrance to the western catacombs at Brompton.

# Kensal Green

The plan for London's first garden cemetery was initiated by the barrister George Frederick Carden, who was inspired by a visit to Père-Lachaise in Paris in 1821. The cemetery was established by Act of Parliament in July 1832, during a cholera epidemic. The Bishop of London consecrated the first 48 acres in January 1833, and the first funeral was conducted a week later. Kensal Green Cemetery is the oldest of London's 'Magnificent Seven' burial grounds. Situated in north-west London, it's the city's oldest commercial cemetery. The cemetery is home to many famous people.

From the funeral of the Duke of Sussex in 1843 to that of his nephew, the Duke of Cambridge, in 1904, Kensal Green was the most fashionable cemetery in England. Its notable personalities include some 650 members of the titled nobility and over 550 individuals noted in the *Dictionary of National Biography*.

The catafalque and hydraulic lift in the Anglican Chapel have been restored to working order, and a plan is in place to restore the building itself. The Friends of Kensal Green Cemetery lead regular Sunday afternoon tours of the cemetery throughout the year. Although at present the catacombs below the Anglican Chapel are not accessible, all tours can now visit the small catacomb beneath the Dissenters' Chapel.

There are three separate sets of catacombs at Kensal Green. The largest and best known is that situated below the Anglican Chapel and its flanking L-shaped colonnades.

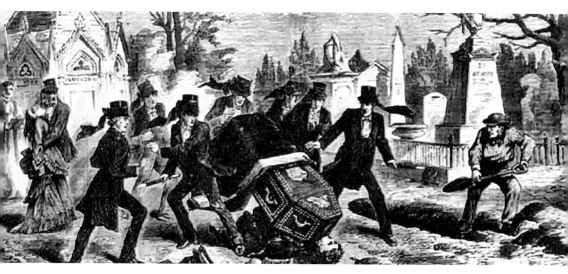

*Above*: Henry Taylor was a pallbearer for a funeral at the cemetery in 1872. As he was carrying the coffin, he caught his foot on a stone and stumbled. His fellow pallbearers let go of the coffin, which fell on Henry and killed him. The *Illustrated Police News* reported on the incident and claimed: 'The greatest confusion was created among the mourners who witnessed the accident, and the widow of the man about to be buried, nearly went into hysterics.'

*Below*: The Dissenters' Chapel, Kensal Green.

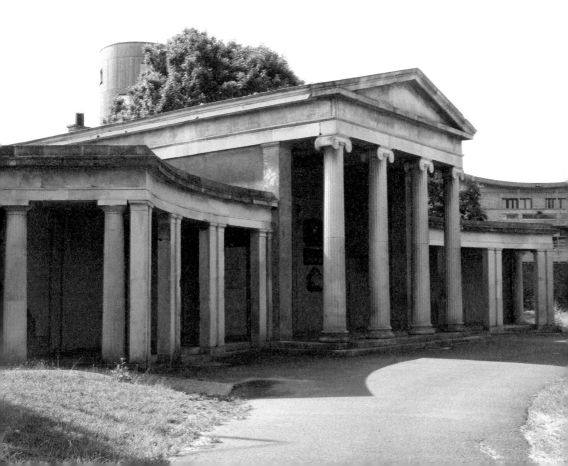

The chapel was completed by 1837. It is rectangular and is constructed symmetrically along six straight barrel-vaulted passageways running north–south with a central east–west corridor. Space was allocated for around 1,000 coffins, laid on stone racks in a series of 216 bays. Access to the catacombs for the heavy lead-lined coffins was provided by a hydraulic lift.[44]

The earliest structure within Kensal Green was actually the northern colonnade with its catacombs below. These were reported to hold 2,000–2,500 coffins and were in great demand. The catacombs extend out in front of the colonnade, forming a terrace.

Sadly, the structure is in a poor state, with many of the memorial tablets in the colonnade above having been lost to vandalism. The entrance to the catacombs was at the west end, but it has been sealed and there is now no access.

The Dissenters' Chapel at the eastern end of the cemetery was built by 1834. It also has a catacomb below, consisting of a series of brick vaults arranged along three corridors. The coffins would have been lowered down into catacomb through the chapel floor and then placed on iron racks. The catacombs were popular from the outset, with 193 burials taking place in the first year alone.[45] The chapel was damaged by incendiary bombs during the Second World War and was later the subject of significant vandalism.

The Anglican chapel at Kensal Green.

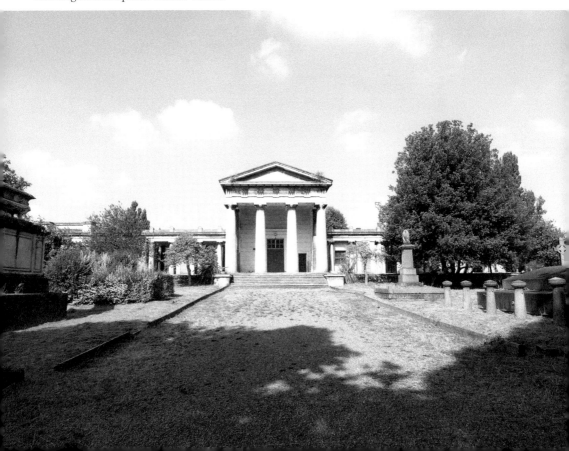

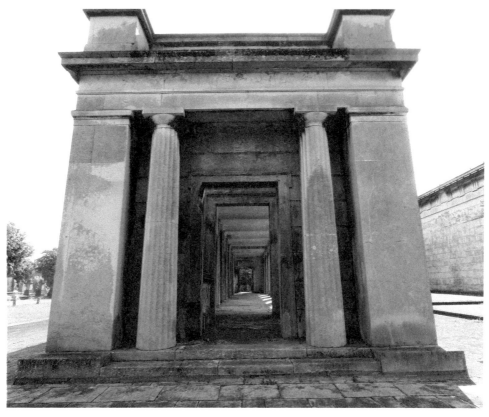

The colonnade on the north side of the Anglican chapel.

## HARROW ROAD CEMETERY.
### Office, 95, Great Russell-street, Bloomsbury.

| Catacombs. | New Catacomb. In Iron or Stone. | Extra Size in Stone. | Old Catacomb. In Iron or Stone. |
|---|---|---|---|
|  | £. s. d. | £. s. d. | £. s. d. |
| Private Vault under Colonnade, for 20 Coffins......... | .. .. | .. .. | 110 0 0 |
| Do. in Catacomb, for the whole Vault .. | 199 0 0 | 199 0 0 | 145 0 0 |
| Ditto, for 16 Coffins .. | 168 0 0 | .. .. | 126 0 0 |
| Ditto, 12 do. .. | 132 0 0 | 168 0 0 | 103 0 0 |
| Ditto, 10 do. .. | 115 0 0 | 145 0 0 | 88 0 0 |
| Ditto, 8 do. .. | 96 0 0 | 120 0 0 | 72 0 0 |
| Ditto, 6 do. .. | 75 0 0 | 93 0 0 | 55 0 0 |
| Ditto, 4 do. .. | 52 0 0 | 64 0 0 | 38 0 0 |
| Ditto, 2 do. .. | 27 0 0 | 33 0 0 | 20 0 0 |
| Do. in Stone only, 1 do. | 14 0 0 | 17 0 0 | 10 10 0 |

[Interment Fees.. Adult, £5 5s.—Child, £3 10s.]

Interment in Public Vault......£4 4s.

[Interment Fees.. Adult, £2 2s.—Child, £1 8s.]

The cost of burial in the catacombs of Kensal Green (here called Harrow Road Cemetery) from John Cauch's undertakers guide of 1840.

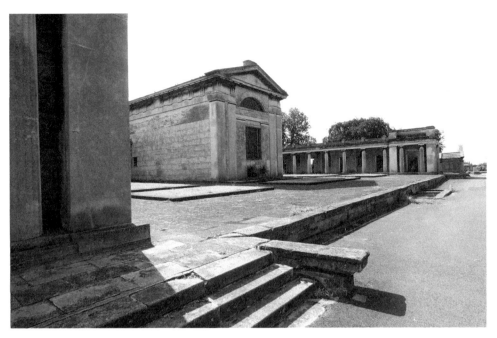

The catacombs run below the whole area of the platform for the main chapel building and its colonnades.

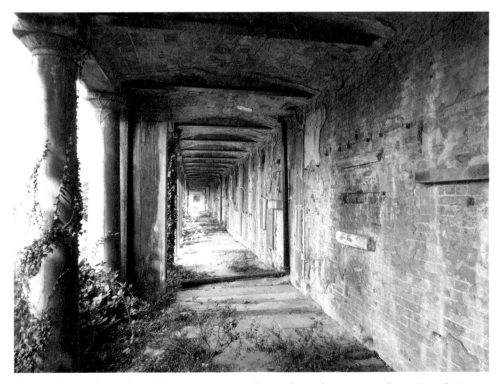

The northern colonnade, which was constructed over the earliest catacombs at Kensal Green.

# Abney Park

Abney Park Cemetery Company established their cemetery in Stoke Newington, which was opened in 1840 as an arboretum cemetery. It was the main place of burial for London's Nonconformist population throughout the later part of the nineteenth century.

The foundation stone for the chapel was laid on the day the cemetery was dedicated. A report in the *Hackney Gazette* in 2014 quotes a spokesman for the Victorian Society at the time of the building being added to their annual Top 10 list, saying, 'the chapel suffered severe vandalism – even the contents of the chapel's catacombs were scattered leading to rumours of black magic.' An article in *Literary World* from 30 May 1840 about Abney Park mentions that 'a temporary chapel has been erected, with excellent catacombs constructed under it'. It goes on to recount that a permanent chapel was being built:

The entrance to the Northern Colonnade at Kensal Green, which has now been sealed up.

The original design for a chapel … included an extensive range of subterraneous vaults or catacombs, so contrived, in detail, as to afford the means, and, indeed, to impose the necessity, of hermetically sealing every depository, so as perfectly to separate the dead from the living. The Directors determined, however, not to encourage the practice of catacomb interment by making any very large provision to that effect.[46]

The costs for being buried in the catacombs at Abney Park varied from £10 10s for a private vault holding a single coffin, up to £126 for a private vault holding sixteen coffins.[47]

An 1869 description of the cemetery includes the catacombs: 'We now walk over to the catacombs and looking through the massive gates down to the door, we wonder who lie in this cold stony death-place. As we enter, the chilliness is awful and repulsive. We counted between fifty and sixty coffins, all in good preservation.'[48]

The catacombs had a 'Cross of Sacrifice' war memorial built on top of them in 1923 and were sealed in the 1970s. More recently, the entrance has been backfilled and the area paved.

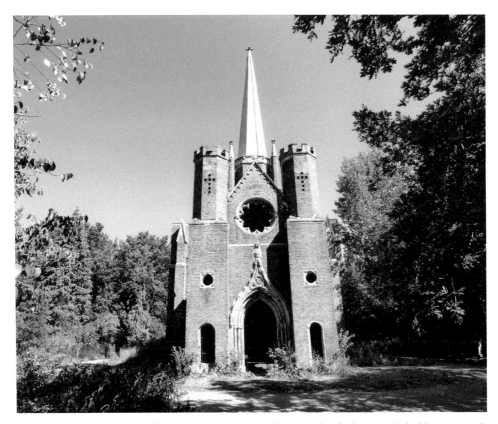

The Abney Park Chapel, following its restoration. The Friends of Abney Park hold occasional musical events and lectures here.

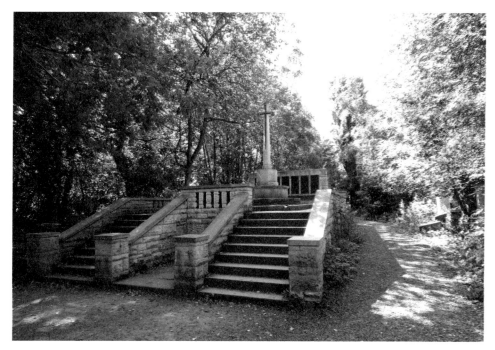

The war memorial in Abney Park was constructed in 1923 on top of the catacombs.

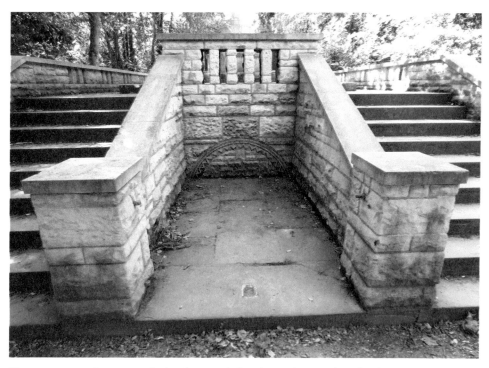

The entrance to the catacombs has been sealed and paved over. There has been no access since the 1970s.

# The City of London and Tower Hamlets Cemetery

This is probably the least well known of the 'Magnificent Seven' early Victorian cemeteries. Originally intended to cater to all markets, it rapidly became used mainly by the lower-middle and working classes, and holds a high percentage of pauper burials. It was consecrated in 1841, although it was not until 1849 that the two chapels within were completed.

An article in the *Illustrated London News* in March 1849 notes:

> The chapels … have just been completed from the designs of Messrs. Wyatt and Brandon and are greatly admired for their purity of style and propriety of arrangement. That erected in the consecrated ground is in the early Decorated period, with a belfry at one angle, in which are some nicely ornamented windows; and at the sides are attached cloisters for the reception of mural tablets, so constructed as to afford an effectual screen from the weather. The chapel appropriated to the use of Dissenters is of octagonal form, and in the Byzantine style of architecture. Beneath both chapels are dry and extensive catacombs, arranged so as to accommodate single coffins or to form family vaults.

The cost of being buried in the catacombs at the time of the opening varied from £10 for the purchase of a catacomb under the chapel for one coffin, up to £40 to by an entire catacomb to hold eight or more coffins.[49]

The site of the Dissenters' Chapel in Tower Hamlets Cemetery was on the raised mound. A temporary wooden structure now marks the location.

The location of the Anglican chapel in Tower Hamlets Cemetery, which was demolished in 1967.

As with so many other structures within this volume, both the chapels were damaged during Second World War bombing and were then subject to decay and vandalism before being demolished in 1967 following the purchase of the cemetery by the newly formed Greater London Council. The catacombs were filled in and there are now no remains of either chapel above ground.

## City of London Cemetery

City of London Cemetery in Ilford was laid out between 1853 and 1855. The unconsecrated part opened in June 1856 and the consecrated ground was not opened until November 1857. It was very successful from the start and is now the largest municipal cemetery in Europe, with over 500,000 burials since its opening.[50]

It has crescent-shaped catacombs, which now also incorporates a columbarium, as the catacombs were not popular, although they are still available for interments. The fee for this today is over £8,000 for a 100-year lease.

The cemetery is also notable as the final resting place of many of the burials originally interred elsewhere. There are monuments marking the spots of reinternments from twenty-two City of London churches and crypts, including St Andrew Holborn and St Mary Woolnoth.

The coffins are sealed behind memorial inscriptions.

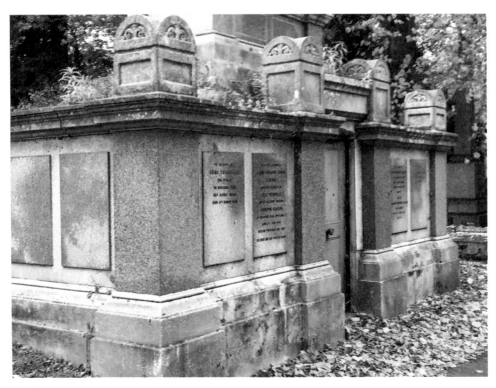

Pedley family mausoleum was built in 1890 in the City of London Cemetery, Manor Park. Two coffins lie immediately behind the door, with several more at the bottom of a flight of stairs.

# Endnotes

1. Friends of Christ Church Spitalfields, Christ Church, Spitalfields: investigations of the burial crypt 1984–1986 [data-set]. York: Archaeology Data Service [distributor] https://doi.org/10.5284/1000367 (2003).
2. Malcolm Johnson, http://spitalfieldslife.com/2014/03/30/a-brief-history-of-london-crypts.
3. Litten, J., *The English Way of Death* (1991).
4. Chadwick, E., 'Report on the Sanitary Conditions of the Labouring Population of Great Britain: A Supplementary Report on the Results of a Special Inquiry Into the Practice of Interment in Towns' (1843), pp. 267–9.
5. Litten, J. (1991), pp. 101–3.
6. Litten, J. (1991), p. 215.
7. Henderson, M., Miles, A., and Walker, D., *St Marylebone's Paddington Street North Burial Ground: Excavations at Paddington Street, London W1, 2012–3* (MOLA Arch Studies Series, 2015).
8. Miles, A., Powers, N., and Wroe-Brown, R., *St Marylebone Church and Burial Ground: Excavations at St Marylebone School, 1993 and 2004–6* (MoLAS Monogr Ser 46: London, 2008).
9. Site Code BFV04, London Archaeologist Round-up 2004, 2011 and 2014.
10. Site code HUD01, London Archaeologist Round-up 2001.
11. Johnson, M., *Crypts of London* (The History Press), Kindle location 2096.
12. Litten (1991), p. 92.
13. Litten (1991), p. 94.
14. Survey of London 1944, Monograph 15, St Bride's Church, Fleet Street.
15. Milne, G., St. Bride's Church London: Archaeological Research 1952–60 and 1992–95 (1997), p. 13.
16. Site Code JAS91, London Archaeologist Round-up 1992.
17. Bateman, N., and Miles, A., 'St Lawrence Jewry from the 11th to 19th Centuries' in *Transactions of the London and Middlesex Archaeological Society*, 50 (2000), pp. 109–143.

18. London Record Society, The Commissions for Building Fifty New Churches: The Minute Books, 1711–27, A Calendar (1986).

19. Reeve, J., and Adams, M., *The Spitalfields Project, Volume 1 – The Archaeology Across the Styx*, CBA Research Report 1985 (York, 1993).

20. Site Code CSM03, London Archaeologist Round-up 2003.

21. Boston, C., Boyle, A., Gill, J., and Witkin, A., *'In the Vaults Beneath' – Archaeological Recording at St George's Church, Bloomsbury*, OAU Monograph No. 8 (2009).

22. https://historicengland.org.uk/listing/the-list/list-entry/1195700.

23. Site Code OLR00, London Archaeologist Round-up 2000.

24. http://hippiecounterculture.wordpress.com/2007/12/03/encrypted-psychedelic-nights-at-the-deptford-crypt.

25. http://transpont.blogspot.com/2008/05/more-tales-from-crypt.html.

26. Mabie, J., 'Eliot, Architecture and Historic Preservation' in Dickey, Frances (ed.) *Edinburgh Companion to T. S. Eliot and the Arts* (Edinburgh University Press, 2016), pp. 76–94.

27. Knight, C., London Vol. 7 (1841), p. 169.

28. Site code SGY05, London Archaeologist Round-up 2005.

29. Cox, M., 'Crypt Archaeology: An Approach' (IFA Professional Practice Papers, 2001).

30. Miles, A., with Connell, B., *New Bunhill Fields Burial Ground, Southwark: Excavations at Globe Academy, 2008*, MOLA Archaeology Studies Series 24 (London, 2012).

31. Site code SJN97, London Archaeologist Round-up 1997.

32. Robbins, M., 'Some Designs for St Marylebone Church with Notes on the Chapels of the District' in *London Topographical Record*, Vol. 23 (1972), pp. 97–102.

33. Miles, A., Ritchie, S., and Wroe-Brown, R., 'Recording and Cataloguing the University of Reading Collection of Coffin Plates from St Marylebone Church Westminster' in *London Archaeologist*, Vol. 14, No. 5 (2015), pp. 231–233.

34. Snell, W. E., 'Frank Buckland—Medical Naturalist' in *Journal of the Royal Society of Medicine*, Vol. 60, Issue 3 (1967), pp. 291–296.

35. http://londonist.com/london/food/dine-with-the-skeletons-of-trafalgar-square.

36. Collison, G., *Cemetery Interment containing a concise history of the modes of interment practised by the ancients; descriptions of Pere La Chaise, the eastern cemeteries, and those of America; the English metropolitan and provincial cemeteries, and more particularly of the Abney Park Cemetery at Stoke Newington, with a descriptive catalogue of its plants and arboretum* (1840), p. 167.

37. Cauch, J., *The funeral guide; or, a correct list of the burial fees, &c. of the various parish and private grounds in the metropolis, & five miles round …* (1840), p. 67.

38. 'The Catacombs' in Friends of West Norwood Cemetery Newsletter (14 April 1993).

39. http://www.apnews.com/b14457dc7c935db31c018013d31ab8d9.

40. http://historicengland.org.uk/listing/the-list/list-entry/1000824.

41. Woollacott, R., *The Victorian Catacombs At Nunhead: A Short History and Description of the Chapel Catacombs, Shaft Catacombs and Eastern Catacombs in Nunhead Cemetery, Southwark* (2003).

42. Sheppard, F. W. H. (ed.), 'Brompton Cemetery' in *Survey of London: Vol 41, Brompton* (1983), pp. 246–252.

43. Cauch, J. (1840), p. 68.

44. Curl, J. S. (ed.), *Kensal Green Cemetery. The Origins & Development of the General Cemetery of All Souls, Kensal Green, London, 1824–2001* (2001).

45. http://www.pastscape.org.uk/hob.aspx?hob_id=1506564.

46. Collison, G. (1840), p. 262.

47. Cauch, J. (1840), p. 65.

48. Baker, T. B., *Abney Park Cemetery* (1869), p. 32.

49. Cauch, J. (1840), p. 61.

50. https://historicengland.org.uk/listing/the-list/list-entry/1000286.

# Links

Friends of West Norwood Cemetery: www.fownc.org
Friends of Nunhead Cemetery: www.fonc.org.uk
Friends of Brompton Cemetery: brompton-cemetery.org.uk
Friends of Kensal Green Cemetery: www.kensalgreen.co.uk
Friends of Highgate Cemetery: www.highgate-cemetery.org
Friends of Tower Hamlets Cemetery Park: www.fothcp.org
Abney Park Cemetery Trust: www.abneypark.org

# Acknowledgements

MOLA
Friends of West Norwood Cemetery
Lambeth Council
Friends of Brompton Cemetery
The Royal Parks
Royal Borough of Kensington and Chelsea
Friends of Nunhead Cemetery
The Rector and PCC of St Anne's Church, Limehouse
The Garden Museum
The General Cemetery Company

Also available from Amberley Publishing

A fascinating look into the capital's lost graveyards, which are often
found in the unlikeliest of places.
978 1 4456 6111 7
Available to order direct 01453 847 800
www.amberley-books.com